THE LITER/
VOLUME III

Lest I forget

Compiled and Edited by
Cheryl Antao-Xavier

An IOWI Anthology

The Literary Connection Volume III
An IOWI anthology

Compiled and edited by: Cheryl Antao-Xavier

Published by: In Our Words Inc. /inourwords.ca/inourwords@bell.net

Book Design: Shirley Aguinaldo

Photographs (unless otherwise credited): Merridy Cox

Library and Archives Canada Cataloguing in Publication

Volume III compiled and edited by Cheryl Antao-Xavier.
Contents: Volume III. 'Lest I forget'.
ISBN 978-1-926926-75-9 (v. 3 : paperback)
 1. Canadian literature (English)--21st century.

PS8251.1.L58 2014 C810.8›006 C2014-905856-X

LEST I FORGET

Lest I forget
 The many hands that raised me
 lifted me when I needed lifting
 Influences that continue to inspire
 my present, my future
Lest I forget
 to be grateful for them.

Lest I look back
 On the vibrant fields of life
 dimming in fading memory
Lest I forget
 the times, the places, the people
 that were ever defining moments

©cheryl antao-xavier

Contents

John B. Lee

AT LEAST FOR NOW

poem inspired by a photograph of Ida Wight
in her home in China in the early 1930s

a lean woman
her long-boned body
draped in a black silk dress
she is seated
in a stiff-spined rocker
her well-shod feet crossed
at the ankles
adorned in high-top shoes
laced almost to the knee
like greaves
she grips the arms of the chair
as though at any moment she means to rise
or rather resist
the weightless phantom
that floats her spectral complexion
from the white collar
of this pale-fleshed visage
she, with the self-assured
physiognomy of the righteous
certain of the purity of her Christian soul
with the rectitude
of a widowed woman
bearing the carriage and posture of
her place in time

surrounded as she is by
the proof—her piano, her fern
her umbrella closed up and hung with its
rainless verdict

and the cut-flowers
long-stemmed and blooming from a slender
clear-glass vase

she is wasp-waisted
angular
doyen of a sun-bleached white-walled room
as on this day
she poses
in her parlour in China
and she means
to be herself forever

at least for now

Photograph of Ida Wight in her home in China supplied by John B. Lee

IN THE BASEMENT OF THE MARY WEBB CENTRE
I HANDLE YOUR SENT-HOME SILKS

in the basement
of the Mary Webb Centre
I handle
your sent-home silks
in what was once
the psalter-scented cellar
of your long-dead father's first church
where I learned
to name the many books of the Bible
in the smaller
glassed-in rooms
of Sunday-morning lessons
where I raced over
the painted cement floors
at Tyro
playing cosom hockey
with a sawed-off Koho
where I sat in a
small circle of village children
being a boy among peers
under the steady guidance
of the reverend Cross
who also came to our school
with stories of Christ
his pastoral face fading
from my mind
like the over-washed image
of old memory
where colour weakens in sunlight
to stain the paper it's soaked in

that same important building
where I sat
with Hope Palmer
sharing her strawberry box social
picnic basket
for the name I'd drawn for luck
her lunch redolent of dill sprigs
and the high pong of untinned salmon
a girl in white lace gloves, looking
as though her hands were dipped to the wrist in milk
and she sported fancy frilled socks
and Mary-Jane-bowtie-patent-leather shoes
a napkin in her lap
for catching the crumbs
as we moved through
the slow confusion of childhood
through youth
not yet blooming
in the contemplative silence
that comes in the awkward quiet
between the genders
brought together too soon
for reasons
they cannot comprehend

that room lost
under the upstairs pulpit and the spires
thrusting up and through the branches of maple
with a thousand-thousand funereal sundowns
draping the roof
in a dark web
with the eternal droning
of the window wells of winter
and the mostly shallow drifting
of shadow-blackened snow

and I am there
studying the oriental embroidery
of a small coat
and delicate slippers
like garments
from the costume chambers
of an actor's abandoned closet
someone famous
in the glory days of Gilbert & Sullivan

everything rain-stained
and threadbare
and tatterdemalion
like time-crushed roses
exhausting their fragrance
in the heart of a hundred closed pages

imagine morning
in the mulberry stain of dawn
after the silk moth harvest is done
with women at their handlooms
weaving
the headspring of beauty
singing Lei Su songs
for the wife of emperor Huang-ti
leaving their blue belief
in the soft fabric of fallen heaven
cut into sleeve shapes
for small-shouldered girls
to wear
playing dollhouse at the farm
those radiant costumes
crossing the ocean
arriving here as though coming home
sailing over moonlit waters
like the light of a golden gloaming
caressing the west coast of America

I feel in this ghost weight of a shining fabric
the drape
of wet smoke
the slow smoulder of fog over bones
and blossoms
of the turning-brown chrysanthemums
of autumn

INTO THE RED MIST

Frank Emerick—First Lincoln Militia (1791-1881)

walking through the smoulder of sorrow
into the red mist
of an unfinished war
into the cordite-fragrant
crimson burn of old summer
from the musket volley
of a violent Niagara night
that fatal flash
of a flaming enfilade
what carried death
to the throat of evening
death to the breath
with a worm in the wool
where it stops the heart
like the deep brand
of a closing-over wound
an ingot cracking the rib
and searing the lung
of a no-longer standing man

what also blasts the snow
and breaks the ice
in the ghost march
of a cold hour
where the land lies
blue shadowed
and clay breasted
with frozen-over forms
of shocked-as-they-fall corpses
braving the unbreachable darkness
like the upheaved shapes of shallow graves

he of the lowest rank
a common fellow
caught up
in the accident of health and youth
at a bellum hour
in the age of mars
among farmers
and all the other one-cow neighbours
and hardscrabble strangers
of a map too young to know
he on the Lincoln flank
who learned at Lundy's Lane
and then in the frost-ache of winter
at Ogdensburg
and again at Crysler's farm
how quick
as a sewn meadow
the scatter-loss of the broadcast seed
of a single season
might green the names
of a dozen anonymous men
then moss the stones
to blacken the marks
of unreadable worth
where only the lichen lives

he my ancestor
he my grandfather thrice removed
survived the conflagration
survived his lost son John
lived on in the shelter of peace
a nonagenarian sire
a free man, Francis
American born
walking the trace lines
of heavy horses

in this foreign field
with gull hunger
worming his wake
under weather of heaven
God-shouldered with rain

John B. Lee is the Poet Laureate of the city of Brantford in perpetuity and Poet Laureate of Norfolk County for life. Born and raised on a Centennial farm in Kent County southwestern Ontario, among the over eighty prestigious writing awards in 2007, he received the inaugural "Souwesto Award," in recognition for work reflecting the ethos of Southwestern Ontario. He has traveled widely in every province of Canada, and in the summer of 1998 he received the Order of Arctic Adventurers for having walked the Weasel River valley crossing north of the Arctic Circle. He lives in a lake house overlooking Long Point Bay in Port Dover.

Frank Emerick. Photograph supplied by John B. Lee

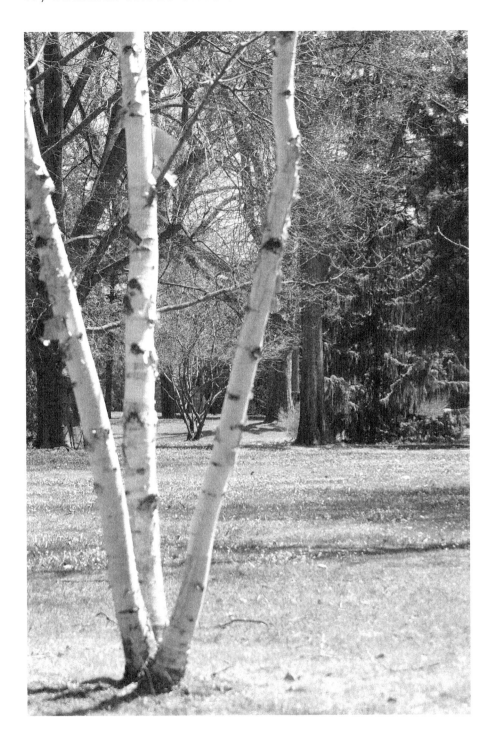

Jasmine Jackman

THE BIRCH TREES

For Doris Pontieri

Pensive
Quietly, gently, softly,
Riding English[1] over a blanket of snow,
Sitting and rising adagio[2] with each stride,
Trotting in a rhythmic ballet in perfect metered time
Amongst the silent white birch trees.
The wind's breath parts and caresses us
As we pervade the stillness of the night air
Leaving behind a trail of horses' hoofs which soon disappear.

The moonlight streams through the naked branches.
The horses pause in a glade of untouched fallen snow,
Heading intuitively to our usual spot.
Although we have taken this path hundreds of times together,
I sense a sadness in you that is
Mirrored by the melancholy of the desolate winter nightscape.
The hooting of the owl says the odds are not in your favour.

We sit in silence, which seems like an eternity,
And marvel at the beauty of the birch trees.
Your eyes glitter as the moon dances across your face
Releasing age-old memories.
A teardrop escapes.
You manage to sigh, "What a perfect night."
Little did I know that that would be the last night we would share
 together.

In the calmness of the following winter's night,
I finally ride alone to our usual spot,
One set of prints through the trees
That tickle with haunting whispers of the wind
Tickling
Falling snowflakes transform into tears
As they collide with my face on their path to the ground.
A sapling appears in the midst with a few beautiful bold red leaves
Dangling precariously from bare branches
Where others have long disappeared.
I know then it is you signaling me from above
That you will always be watching over me
Among the white birch trees.

WHERE THE PAVEMENT ENDS...

For Africville

A once-thriving seaside community
looking out across the pond to a colonial history.
Shades of colour too close to the city—Move them!
Honest workers in their adopted country, dispossessed of land
Shelved on the edge of the city where the pavement ends
Devoid of government support or utilities.
Pride of ownership grew
Despite minimum standards of care refused.
Second-class citizens doing their best.
The church, the heart of this makeshift city, encouraged them.
The life you live depends on what you decide you are worth.
Amnesia of the proud Maroon history and Loyalist past
Thrived in their veins.
The community grew with love and brotherhood
On the outskirts of a city that cut them off
Ignoring the true freedom promised.
They became economic slaves.
Cutting through train tracks and dumping city garbage there
Making living and boring children—a dangerous affair.
Need for more land caused the government to give the command:
"Poor living conditions cannot continue to stand."
When people failed to walk away
The institution misappropriated it all
With the swipe of a pen.
Like thieves under the cloak of darkness
Houses disappeared
Bulldozers flattened the houses built with sweat and ingenuity
And carried away the heart of the city
Before people woke.
Lifework of memories shattered
Family security, self-worth and land gone.
Moved them to the slums
Separate and out of sight.

Turned the clock back and made them slaves again.
Silent people-porter and the maid
Repositories of bitterness
Denying knowledge of heroic ancestors.
Because of their vision they survived
Despite conspiracy to destroy them.
Generations of men
In the shadows of the civil rights movement
Just being born.
The memory of the book of Negros in
Africville still remains.

THE BLUE CANOE

In memory of my two dear friends, Andy Herman and David Greaney,
whose lives were arrested too soon.

In a school whose goal was to make men out of boys
a group of 27 eager students and four teachers, tracing travel routes of
 past explorers
in special newly built blue cedar canoes, set out on a character-
 building odyssey
on Lake Temiskaming to James Bay on a bright summer June day
Nine students in each belly
but who knew instead of protector these canoes would end up
 becoming
artefacts of masculinity and poor planning
While their friends back home played hide and seek, traded cards and
 pulled on girls' ponytails
these young boys toiled away in the cruel summer heat
Sleep-deprived and shivering in the early morning frost
with only a compass to guide them they headed off
in the morning dew keyhole lifejackets providing the only warmth
as their canoes cut through the frigid waters
navigating farther and farther from the shore the convoy of canoes
 swayed
on their way to noble manhood
Met by unruly winds in mid-travel the lake rose up out of its bed
causing ocean-size waves to materialize above everyone's head
the sun escaped as darkness descended
tossing the canoes to and fro
Unable to maintain the façade of men
the young boys called out for their mothers
as one canoe after another tipped
Cries of help echoed in the dead of night captured by waves
that carried them away into the depths of the lake unanswered
Keyhole life jackets unable to save lives became guardians of souls
Parents sleeping at home with dreams of their children transforming
 into men

could never have fathomed the horror that besieged their loved ones
 instead
While their sons longed for the last warmth of their parents' embrace
Despite their valiant efforts at survival
many were lost to the icy water graves of Lake Temiskaming
Cheated out of their lives
Sunrise displays in the wake of the water the angelic china dolls
 floating looking into God's eyes
Calm waters belie the tragedy that took place hours before
Souls swept away in the sudden fury
in the midst of a group-of-seven landscape
The haunted chatter of twelve excited boys and their teacher
on their first excursion across the lake could be heard
 "Remember me" whispered with each wave lapping the shore
running shoes without their owners line the beach
All that remains are the bobbing of the blue canoes
Emptied
tethered to trees
others upturned on the shore
leaving more questions than forgiveness.

RAVAGED AT WAR

For 'Comfort Women'

He looks at me.
Does he know?
Although it was 70 plus years ago
and I have grandchildren of my own,
My husband stares right through me.
Mind of steel and a will to survive
allowed me to live to mother a child.
But does he know?
The shame of a young girl stolen,
sent to foreign lands, enslaved to perform the bidding of soldiers,
Japanese men as they made their way across the Korean border
to fight a war that had no psychological end.
Does he know?
Deceived to leave home,
an immature doe whose innocence was ravaged at war,
the wounds on my mind continue to scab over, heal, blister and bleed.
Secret shame not of my own imprisons me
in a labyrinth of a past no one wants to claim.
Will I see justice in my lifetime?
Will leaders step forward to say, "We were wrong," "We are sorry,"
 "Please forgive us,"
or will history be rewritten,
our hurt erased and silenced?
I fight back self-loathing and the pain of degradation,
Isolation
Introspection
Desolation
Hoping he knows.

A NOTE TO MY TEACHERS

Inspired by James Baldwin's A Talk to Teachers

Kindergarten

My first day of school, I couldn't wait—
I was up and dressed before anyone else was awake.
I remember pulling my mom along as I rushed toward the school
where my sister went each day.
Upon arrival I waved mom goodbye and saw teardrops in her eyes.
She hesitated for a while and then she was gone.
I was ready to find new friends whose names were different from mine.
Good morning, good morning and how do you do? The sun has risen, the
* sky is blue. Good morning, good morning and how do you do?*
This was the way we greeted each other every morning,
bowing and turning and bowing again to the next person.
The routines, procedures, manners taught were many and I learned
 them all,
and worked to enforce them too.
I was amazed that you knew all our names.
You quizzed us about curious facts and wonders of the world
and taught us what all those squiggly lines on the board meant.
When Johnnie wet his pants for the tenth time
you just breathed and stayed calm and didn't make a scene.
Your belief and optimism in us overflowed.
Juice and cookie time just before our nap was the highlight of my day.
As teacher's pet I got to hand them out.
Patterns, blocks and playing house, fireman, doctor, finger painting
 and singing too
all came to end, which seemed far too soon.
Tidy up! Tidy up! Everybody tidy up!
I learned to wait my turn, queue up and walk in a straight line,
a perfect soldier in the making.
Obedience and patience were always on my mind.

To be greeted by your smiling embrace
made me feel that I could do anything.

You inspired me to greater heights.
It was contagious and I never wanted to go.
Seeds of curiosity germinated,
but then there came a time we had to leave you and move on.

Primary

My friends became my adopted family.
Together we stole kisses and harboured secrets,
soon learning that anything two people know is really no secret.
You taught us right from wrong, please and thank yous and respect for
 the flag,
how to use an abacus and count on our hands.
We played carelessly in the innocence of orange crunch autumns,
frostbite winters through to the fresh dew springs,
asking questions about half-truths told or about why penguins don't
 sing.
Why, who, where, what, why not, and how—an incessant articulation
 of curious minds
You praised students by saying "You are so smart."
"I can do it by myself"
My potential grew the more I learned and understood.
We fought for stars and "great," "brilliant," "good job" stickers,
for recognition of work done,
to show that we were smart and not dumb.
Like a proud parent you encouraged us by making learning fun.

Junior

Name-calling was rampant.
Students pointed out what they saw that was different.
You were "shorty," "two-eyed,' "skinny mini," or an "N—"
something I had never heard until I started school.
Complaints to you fell on deaf ears.
You stood by the guidelines as I was chased around at recess each day
saying: *sticks and stones will break your bones but names will never hurt*
 you.
But that word did.

It seared itself into my mind like a tattoo releasing anger, frustration
 and hate.
Friends, we professed our loyalty to each other right to the end.
Further rules and discipline learned along the way
with the required rote learning of multiplication and regurgitation of
 facts to date.
Budding cherries on young chests.
Boys now part of the mix—furtive stares you hoped would produce a
 reciprocal smile.
Spin the bottle became a terror for all when I was part of the group.
Colonized mentality left me uninvited to sleepovers because my skin
 was too dark.
Remember when you challenged my birthright,
saying "There are no black people in England—where are your parents
 from?"
Incessant chattering students—unable to catch our attention
you had to flick the lights on and off.
Bullying and name-calling by peers,
social recognition—birth of sedition,
goodbye to ignorance and stares.
One look in the mirror—
no teachers nor students shared my ebony hue,
then all of a sudden I realized I no longer fit in.
You missed all this happening in the shadows…had no clue.
We huddled around you as you serenaded us on your guitar
at the back of the class,
showing that you had feelings just like us.

Intermediate
Absorption of facts,
sports and extra-curricular activities
kept me busy and often missing class,
but never a problem because my work was always done.
Others engaged in borrowed and stolen kisses, promises delayed.
I remember when Pauline told you to "flock off like the birds."
Your face became as red as your shirt but you kept it together,

you asked her to go to the office.
She gave you the finger and went home instead.
Pubescent teenagers were never easy—
to teach is to change lives forever.
You went to bat for us against injustices involving your peers,
willing to risk social isolation—for that
I have thanked you from the bottom of my heart for years.
Who should be educated and where?
 Straight to work, apprenticeship, technical, academic high schools …
 fears/cheers/there/
uneven opportunities—you felt the need to guide parents to the path
 their children should take.
I like the protection and care you showed to us. . . you really cared.

Senior
Rotation.
Teachers were focused on teaching subject matter
and getting through the curriculum,
cementing western values while omitting others.
Opportunity to correct generations of misinformation missed.
Race has contributed nothing of value was the obvious conclusion.
Colour-blind system woven into a fabric of systemic oppression,
unable to tell the difference between equality and equity positions.
But a few teachers taught from their heart without quoting from
 books,
spending their lunchtime counselling and socializing with students.
In the morning and after school these foster parents were always on
 the hook.
Who is marginalized and who is accepted?
Finishing at the top or bottom—
the grade is all that matters.
Forward-thinking teachers instilled the need to press through
despite hardships experienced,
preparing us for the entry to life's business plan,
to have the mindset that you may not have conquered the world…yet,
but some day you will.

WE MATTER

Forgotten females
Hidden in the shadows of colonial oppression
Justice denied
Wampum belt of elders destroyed
Indigenous values repressed
A worthy life insignificantly strewn among the forests and highways
bones picked dry by bitterness and hate
voices silenced by indifference and the sour compromise of complicity
Lives deleted
Stories buried
Families ruined
The ground swells with the voices of the marginalized screaming to be
 heard
riding on the back of a tortoise shell.

Jasmine Jackman *is an award-nominated educator, mentor teacher, and social justice advocate. She has been working with underservice youth since 1980 and has chaired both professional and community diversity committees. She sits on the board of the United Nations Association of Canada Toronto Region, Skills for Change, Bridging the Gap, and the African Women's Acting Association, which work to engage the public in diversity initiatives that elicit empathy, hope, and action. Jasmine is currently enrolled in the doctoral program at the OISE at the University of Toronto in policy and leadership. She resides in Mississauga, Ontario.*

I.B. Iskov

TED'S LONG WAKING

In Memory of Ted Plantos

Sitting in a Muskoka chair
on the Lotus coast
Ted built frescoes
under a strawberry smacked sun
inhaled music
and beer from Old Niagara

Foaming over the rim
in darkness and the coming dawn
he breathed stars in timeless orbits
carnivorous rhythms
strobed the dance floor

Songs of the fishermen, the sea
howled in his head for days
the early sermons composed
in a swallowed fire
waiting for a leaf to fall

On solid footing he climbed splintered fences
through ashes and disjointed drain systems
he devoured smoke
like a contradiction
knowing the streets were hungry

Rushes of breath stuck between eyes and flesh
mushroomed into naked clouds
the moist white
flowers wavered

over old bent rough bark
his shoulders
two serpent columns
groaned with the wind
through stone and snow

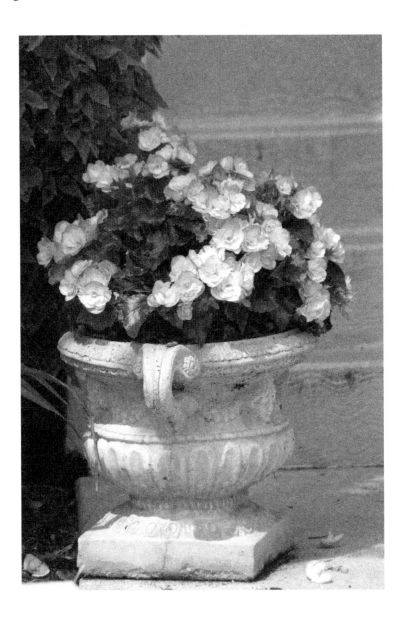

WHEN HE DIED, HE TOOK
ONE LAST POEM WITH HIM

~ For Earle Birney

He lived his life like a leaf
dancing and singing
from a hazel bough
in winter, he'd simply move
the tree indoors

His words etched
a million faces on paper
burned a memory in metaphor
cities of parchment
exploded like firecrackers

His hands molded pictures
like a sculptor he'd fashion
shadows in holes
and everyone would gasp
at their exactness
the ritual was a myth

He sleeps with one last poem
as a blanket to cover
the decay of genius
now and forever

I.B. (Bunny) Iskov *is the Founder of The Ontario Poetry Society* www. theontariopoetrysociety.ca. *Her work has been published in several literary journals and anthologies. She has three full collections and lots of chapbooks. In 2009, Bunny was the recipient of the inaugural R.A.V.E. Award, Recognizing Arts Vaughan Excellence in recognition of outstanding contribution to the cultural landscape of the City of Vaughan. The award is for Art Educator/Mentor in the Literary Arts.*

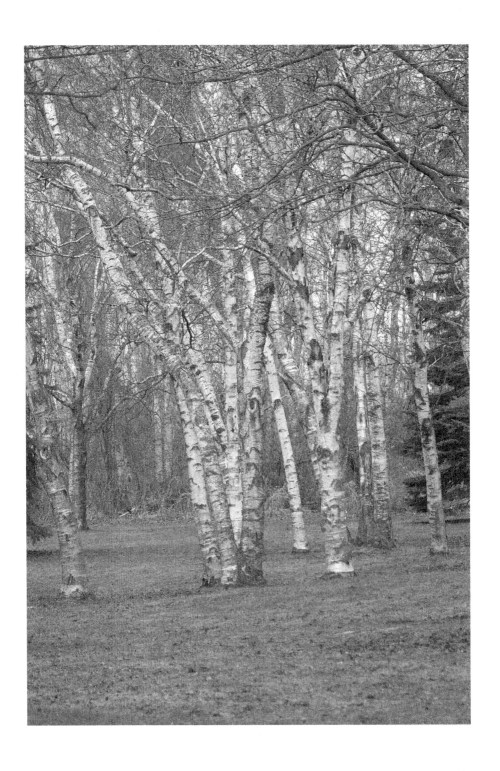

John Ambury

AN UNEXCEPTIONAL MAN

"I told your mother he'll be fine. She should stop nagging. She shouldn't make it hard for you."

My fiancée's father, Mr. Kronberg, had picked Ursula up after work a week or so before the wedding to tell her that in person. She was relieved, but also a bit shocked: as far as she knew that was the first time he'd ever stood up to his wife.

I was not Mrs. Kronberg's idea of son-in-law material to put it mildly — she had made it clear to Ursula that she thought her daughter was making a big mistake. Of course there were minor problems; but we survived the preparations and the wedding and even the first year or so of marriage without any serious in-law upsets.

My own father was strict and rigid, the Army Sergeant through and through. He was to be obeyed, period. I didn't want to be that kind of husband and father, but he was the only role model I had.

Until Arnold Kronberg. He'd been in the Army too, but he didn't seem to have picked up the same ways. (My father and Ursula's had been on opposing sides in the war, mine Allied and hers German; but we established that they were never even close to being in the same place at the same time, so they hadn't literally shot at each other!) He was too easy-going to demand respect, but he quietly *earned* it. I was too stubborn to be quite that easy-going, but I compromised.

On the other hand, Ursula was determined not to be difficult and controlling, like her mother. She succeeded very well. But she was too stubborn to bend to her husband's control; so she compromised as well.

* * *

He watched my efforts silently until I put the electric drill down in disgust. "Should I try?" he asked.

"Help yourself." I was sweaty and frustrated and not feeling at all gracious.

He was totally calm, something I'd often observed and always admired. He sorted through his well-organized toolbox and came up

with something unlikely: a long tempered-steel rat-tail rasp with the tip split. Not a real drill-bit, a MacGyver. With his usual smooth, assured movements, he released my concrete bit, fitted the rasp into the chuck, and tightened the jaws. He set the split end of the rasp into the hole I'd started. He gripped the drill firmly with both hands and squeezed the trigger.

It was hard going. He pushed from his shoulder, backed off, and pushed again, the way you do with a tough drilling job. But he seemed to have a personal rhythm that made the stubborn concrete yield to his will: slowly, the rasp bit advanced. Finally, we heard the break-through sound from inside the house. "Wow, great!" I grinned.

"*Ja, gut,*" he smiled. He was pleased, but not excited — he'd known it would get through, eventually.

Together we fed the wire through and made the twist connections. It was his deft thumb that smoothed the caulking into both ends of the hole, a technique I could manage but had never truly mastered.

He had his electrician's papers from Germany. But bringing his wife and daughter to Canada and supporting them here was more important to him than re-qualifying for his trade, so he worked at whatever jobs he could get. One of those jobs was at a high-end kitchen cabinet factory. They let him use whatever scrap he wanted, and work in the shop at night. He created professional-looking plant stands, shelves, radiator covers, and tables for his home; and a number of pieces, including a beautiful set of three nesting teak end-tables for ours — his wedding present.

He never owned a house in Canada. He always improved whatever place they were renting, but much of his abundant skill and strength went into working on our house as if it were his own.

* * *

"Pops got lost!" I could hear Ursula's distraught mother crying on the other end of the phone. Her husband had passed his driving license renewal test; then had become disoriented when trying to leave the Ministry of Transportation parking lot. He did find his way home, somehow, but several hours later.

That was the beginning. Soon he was getting lost in his own neighbourhood.

This was a man who had operated a taxi in the Baltics back when few people could drive; and who had been a confidant and trusted driver for the British Legation before the war and for the occupying officer corps after the armistice. In Montréal, he had taught his daughter to drive—very well. From Toronto he took his family on many excursions: day-trips to Kitchener and Niagara Falls and Lake Erie, longer trips around Ontario and upper New York State. After he retired he drove himself and his wife to Florida for their annual vacation. His car was his pride and joy. Always renting a garage if their apartment didn't have one, he changed his oil and spark plugs and winter tires and even did body work himself, keeping his two-tone Chevy Bel Air or his classic black Rambler running smoothly and looking like new. But now he had to give up his licence, and never drive again.

Ironically, he died some years later from the after-effects of a relatively minor car accident. He wasn't driving, or even in the front seat.

* * *

My own father taught me a great deal about woodworking and electricity, tools and cars and gardening — all the important skills a man needs. But there was little to be learned at home about patience and quiet determination, about mutual respect and listening to a co-worker's ideas. Those lessons I absorbed from Arnold Kronberg.

PERFECT SHOT

George and I needed to escape from the disturbed-anthill bustle of our big family. A peaceful walk in the bush for tin-can target practice was a good enough excuse to get out of the madhouse. The sun was midsummer-hot and the oppressive humidity made it worse, but at least the bush offered some shade.

My brother stopped abruptly, raised the rifle, and squeezed off a round. Maybe thirty yards ahead of us, a small bird I could hardly see tumbled from a branch.

We found it in the undergrowth, lifeless, shot through the head. I was dazzled by George's marksmanship. He said quietly, "That's too easy."

A couple of times we had gone duck hunting with Dad and his buddy Jim. I don't remember any hunting lessons, other than "follow the duck, pass it, shoot when you're ahead of it" and "don't shoot them on the water." Safety training was covered by admonitions to break a shotgun open to carry it, and of course never point a gun at anybody. Beyond that we were apparently expected to learn by experience. I took a few shots, but never hit anything. I don't think any of us did: I don't remember ever taking ducks home for the table, anyway.

Many years later, when he had a small farm, George sometimes slaughtered chickens and rabbits they had raised for food. They froze some and shared some with neighbours. That was the natural way to live in the country. Like most of the locals, he kept a loaded .22 on the window ledge in the mudroom, to ward off destructive species such as foxes, crows, and voles. I suspect his was more talisman than weapon — I'm sure he never shot anything with it.

* * *

Too easy. He scuffed a shallow trench with his boot, rolled the bird into it, and covered it with mulch. He never went hunting after that.

CREAM SODA SUMMER

"Johnny, go get us four bottles of cream soda. Kids have to share." Dad counts out the exact change into my hand. I know to get just what he says: not Coke or ginger ale or root beer — cream soda.

I'm finding girls' pick-up softball pretty slow to watch. But any outing with the whole family is special. It doesn't matter that the six of us have to sit on a blanket on the grass because the few bleachers are occupied by the players' families and friends.

And anything bought, not brought from home, is a rare treat. So I happily clutch the coins and lope over to the convenience store across the street.

Returning with the cardboard carrier (four bottles in the corners, two empty spaces), I approach our blanket from behind. I can tell that Dad isn't really following the game with his old army binoculars — he's watching the players. They're cute girls, barely older than my kid sister. Snug tee-shirts, skimpy shorts, long legs.

You learn to be a man by seeing what men do.

The cream soda is pink and refreshing: cold, sweet, bubbly. I'll have to go later and get the deposit back. If I'm lucky, Dad may let me keep the eight cents.

John Ambury *returned to writing poetry in 2009 and short fiction in 2014, after a long hiatus. His work is widely varied in both subject matter and form. His poems have appeared in numerous anthologies and periodicals; his first collection,* Moving Waters, *was published by IOWI in June, 2016. John belongs to the League of Canadian Poets (Associate), The Ontario Poetry Society (Executive), the Writers and Editors Network (former Board member), and other groups. A frequent reader at Ontario poetry events, he freelances as an editor, proofreader, and book reviewer.*

Photograph of author (aged 11) with Marlene Dietrich, supplied by author

Ed Woods

MY MEETING WITH MARLENE DIETRICH

I was 11 years old when my mother kept me home from school because we were going to meet a famous person. I did not know Marlene Dietrich but I carried a paper bag with a gift for her and off we went by streetcar down to the Royal York Hotel. It was impressive and I was in awe of the luxury. My mother spoke with someone who said something along the lines of they would try. The phone call was finished we were told to go to the elevator and up to her floor and there will be a gentleman to greet us when we exit.

He escorted us from the hallway into a massive suite of at least two greeting rooms and the bedroom. There before me stood a woman who invited me to sit down on the sofa and began to ask me all sorts of questions about school and my interests. To this day I do not recall the questions or my response.

At some point Ms. Dietrich said I hear you have a gift for me. I handed over the paper bag and out came a serving tray. In those days etching upon aluminum was a popular craft at recreation centers and my grandmother finished this one but it was also the first time I had seen it. It represented Canada and had the flags and coat of arms for each province and territory and the edges were flared up in what I thought were ragged edges of a saw-tooth pattern upon probably twenty ridges. Later in life I thought of it as a sine wave pattern with rough edges. Ms. Dietrich accepted it with joy and gave me a hug. Then I had part two of this gift which was a new silver dollar. We conversed for a while then Ms. Dietrich asked if I would like to see her scheduled performance at the show which my mother said out loud "Yes he would."

All I remember is this huge room with hundreds of seats and we were in the front row. During the performance, in between songs, Ms. Dietrich had the house lights turned on and said to the audience: "I would like you to meet a new friend from this afternoon who gave me two gifts of Canada and here he is in the front row. Stand up Eddie." My heart was racing and I thought it would explode with so many people

cheering as my mother said to me it was for being good and giving a gift. The lights dimmed and the performance continued.

The show ended and Ms. Dietrich's manager came to us and asked me if I would like to meet some of their friends but I said I had to be in bed early for school and this is when my mother said I could stay up for this time only. Off we went to a room full of many people and lots of pictures were being taken by the old style cameras where the flash bulb crackled and was hot when ejected from the holder. I sat on a sofa again with Ms. Dietrich and she wrapped her arms around me in hugs many times.

One point I remember was that some men by an open window were helping another man back inside as he was partially out the window. I never knew what alcohol was or its effects and didn't understand he was drunk and tripped near the window. When Marlene asked what I was laughing about and I explained, she too laughed. We were there for quite some time when the manager asked me to present Ms. Dietrich with a silver dollar again for the cameras. I did and the flashes went off and I was seeing spots for some time.

It was time to end the gathering and as we went down to the lobby with her manager he said he would pay for our parking, but upon hearing we arrived by transit and it was late he ordered a taxi and billed it to their room.

The next day our pictures were on the front page of The Toronto Star and it was exciting. My teacher didn't believe my reason for not being in class the previous day until she looked at someone's newspaper and told me I was now famous.

Years later I found out the entire truth about my privileged meeting. Ms. Dietrich had a very cruel reception in Montreal with reporters asking her about personal relationships and collusion with Germany during the war and she was dreading this press conference after the show. When my mother asked the concierge to call up, her manager said this was perfect and to send us up. My attendance at the show was great but afterwards we went to the press room and apparently, from my mother's account of things, every time a reporter asked a sensitive question, Ms Dietrich would place her arms around me in a hug and respond: "Now is this question appropriate to ask in front of my young

friend here?"

Reporters were stifled and could only stick to decent questions although by today's standards their questions were tame. I had a story and pictures for life.

What made me never forget this account was the fact that Ms. Dietrich treated me as if I were one of her grandchildren and totally focused upon me with questions and lots of hugs. I never forget that day even though later in life people could say I was used for a different purpose. My reply then and now has always been: "If you must be used, then be used by one of the worldly greats."

ENJOYING A CIGARET, Miss Dietrich is shown here at her reception in the Royal York. This is her first visit to Toronto

WANDERER

A familiar homeless lady
pulls a shopping cart
bags heaped higher
than her original dolly wagon
Dragged around as if
a pyramid bound
Egyptian stone slave

My image may fool me
for I feel her goal
is always the next block

Enroute to work
cold winter morning
before sunrise
I retrieve money
from a bank ATM
She is at rest
beside the kiosk exit
curled up against a heater

I place a few bills
into a deposit envelope
to slip under her hand
extended past her head
as if in a dream mimic
of the Statue of Liberty

There is not enough time
to ask of her plight
but far more than she
could ever imagine
I understand homelessness

VOLUNTEERS

Nursing Homes or Care Facilities
are the most difficult
Befriend those who truly like you
as they reach the end of their lives

No dishonesty or collusion
just desperate to avoid despair
and you meet the requirements
of their life long contribution
to society and earth

Each story or tale relived
as they see it or recall
Some survived wars, horror
nothing is beyond imagination

My obligation is not to forget
contributors of living history

Outside in the sun today
I toast to a departed soul
taken away this morning
Evening dusk glow
filters a sparkle
through my wine glass
as if a modern hourglass

CAREER LOST

I wander below a landing flight path
amid sequence strobe light towers
in unacceptable impairment
and view landing gears wings and rivets
and taste slick exhaust of engine technology
then tire squeals signal a journey's end

Tenacity to be a jet pilot
skilled and task orientated
in an envied career choice
was a reach too far

Age entered the quest
too old, no matter what
Time kicked away my foundation
as a tide can erode
even the strongest of castles

Today I delivered pilot uniforms
to a high end tailor and knew
I should be wearing one

In sadness I caressed
their golden shoulder bars

CROWDED ROOM

My living room is a nightmare
difficult to navigate
with so much in the way
amid thunderous noise
In fact the entire apartment
is choking me out
and it stinks in here too
I never knew my life
would end up this way

I only have myself to blame
for a lifestyle of impairment
Every time I go to get a drink
the Elephant in the Room
tends to get in my way

DILEMMA

Ma and Pa own this diner
on a lonely stretch
of Ontario highway
only a few parking spaces
Seated upon cruddy counter stool
I understand why

I try to think of what to order
what is the least dangerous
to health and timely travel
a hospital stay will delay my plans

The muffin is very creative
never saw wheat look like that
The fish and chips give off a glow
possibly radioactive mutants
The soup looks as if mine tailings
closer to Sulphur surprise
yet I am starving

Peanut butter and jam again
nutritious and safe

TIME IS PRECIOUS

I volunteer often
in a nursing home
Today yielded a surprise
a favoured resident died

We attached our lives
at the end of lives
I live his stories and hardship
and shared antics or laughs

Time is precious
even more so
when true friends
suddenly drop away

Ed Woods was born in Toronto and now lives in Dundas, Ontario. Through workshops with established writers he received encouragement to expand upon life experiences through poetry. His topics range from the serious to comedic, with observations or insight written from the heart.

Peta-Gaye Nash

ONCE A MONTH AT PONDEROSA'S

"This place is cold, man."

"It's winter Dad, and we're in Toronto. What do you expect?" Why did people always state the obvious?

He was visiting from Florida. I looked glumly at the snow piled outside the window.

"I dunno how people can live here. How can you live in a place like this, Catherine?" It was more of a statement and not a question so I didn't answer. We sat in Swiss Chalet eating chicken smothered in sauce and French fries and staring out at the cold January landscape. I glared at him for a moment then shrugged. I imagined that if I said I hated it, he would worry that I was unhappy and if I said I loved it, he would know that I was lying and still worry.

"Can I go to the bathroom?" asked my daughter Savannah. I rolled my eyes and got up resentfully.

"Again? You went just before we got here. She was potty training and I had to stop at a gas station not half an hour before because she needed to go.

"Come on. At least you're out of your snowsuit." I grabbed her hand and pulled her along. When I returned to the table, Dad had finished his chicken. I let out a long sigh that went unnoticed. Dad looked up at Savannah playfully, his eyes crinkling with amusement.

"Who is Grandpa's girl?"

"Me." Savannah giggled.

"Who is Grandpa's sweetie pie?" Dad gently prodded Savannah's tummy. I had no cute nicknames for her. Come to think of it, I never called my daughter anything but Savannah. I stared out the window, the odd man out.

Savannah reached over to hug Dad and knocked over her drink. Cranberry juice spread on the table like a blood stain.

"Jesus, you're so clumsy," I shouted. "Leave it, Dad. I'll clean it up," I snapped thwarting his efforts at cleaning up.

"You shout at her a lot. I don't like it," said Dad, looking at Savannah. I glared at him but he didn't catch my eye.

"What?" I was incredulous. This would have been a good moment to send his plate of Swiss Chalet chicken bones flying into the wall. My face got tight. "You should not be talking. You, who shouted at me for my entire childhood! I can't believe you of all people, are saying this." My voice felt raised but I knew it was still a respectable octave below an outright yell.

Dad's voice was unperturbed, or at least, he was trying to keep it that way. But his eyes still didn't meet mine. "Yes, I wish it had not been that way. We live what we learn but it doesn't make it right. My father shouted at me and his father shouted at him."

I looked out the window at the empty parking lot and thought about my own childhood. I had wanted a father like my father's younger brother, Albert. He was a jolly old Santa Claus type with wavy white hair and an infectious laugh. He called his daughter, Patricia, my cousin, a princess. My father had no cute nicknames for me and now he was calling Savannah, sweetheart. The only thing I remember him calling me was stupid, especially when I couldn't figure out those math problems they said were so important. Why did Patricia get to be a princess and I got to be stupid? Patricia and I had the same hazel eyes, the same curly brown hair that we wore tightly braided, the same brown skin and spindly adolescent legs. The difference was that Uncle Albert was happy to have Patricia.

I don't know why I couldn't get those math problems. One-minute Dad would be explaining it to me and he'd ask, "Do you understand?" I was busy studying the way his full lips parted and closed, the way his brown wavy hair took off in all different directions and how his voice was so deep and masculine. I drank in his woodsy smell, so different from my mother's scent of vanilla and perfume so of course I didn't understand and I was never ready for the explosion that erupted sending my math book across the room. My body remained intact but my insides were blown apart, shattered as the book flew through the air, hit the door and dropped like a shot bird.

Sitting now in Swiss Chalet, I realized with a jolt and that odd feeling of impermanence, that Dad's wavy hair was now white and his face

held only the faintest memories of the hard angles that once defined his strong jaw line and sharp nose. His lips had also thinned.

"Your dad shouted at you?" I asked softly.

"All the time." I raised my eyebrows in disbelief. My grandfather had been mild mannered and gentle. As if he could read my mind, Dad said somewhat bitterly. "The mellow person you knew was not the person I grew up with."

I looked out the window. It was dull and grey and I longed for the time when the trees would be covered in green. "Dad, you didn't want a family did you?"

"Of course I did."

I remembered the stark difference between my father and his brother, Albert. The former scowled and the latter smiled. "You didn't act like you wanted a family," I said accusingly and felt the unwelcome tears begin to flow. I held the napkin to my eyes. Savannah seemed to intuit that this wasn't a time to talk and she popped a ketchup laden French fry into her mouth.

"I was young. I didn't know better and your mother and I just stopped getting along. She wouldn't talk to me. She only talked to you and your brother. I couldn't stand the weeks of interminable silence."

I didn't remember it this way. It was Dad's silences I remembered and they enclosed him in a glass room where no one could get in. Not Mom, not me, not my brother Daniel. No one was allowed to knock at the door. Dad was entombed within bullet proof glass. We were outside, puzzled, timid, walking on eggshells lest one word of ours pierce that glass tomb and it shatter, erupting with flying pieces of shard that could pierce us straight to the heart.

"Dad, do you remember Ponderosa's?" It was a long time ago but the smell of the Swiss Chalet and the salty taste of fries brought back the memory.

"Yup, those were some great times," he smiled nodding. I felt puzzled that we could have such different memories of the same events. I frowned but didn't say anything. When we were a proper family, back in the late 70s, long before my mother carted her belongings out of dad's life, we went out once a month to Ponderosa Steak House. Dad always had sirloin cooked medium with mashed potatoes. Mom had rib eye and

rice with vegetables and I can't remember what my brother Daniel and I had, except to this day, we both love steak. It seemed to me that Dad felt obligated to take us out since he sat away from us, while Daniel, my mother, and I sat close together. Memory might not be reliable but mom spoke softly to us and the only time I remember dad speaking was to give the order to the waitress and to ask for the bill. The silence is how I imagined the desert to be, dry and barren and never ending. I wanted to fill up that dry, arid silence, to quench my thirst for what other families seemed to have but I couldn't so I drank and drank soda pop until I had to go to the bathroom five times during dinner and everybody got annoyed.

Over dinner at Ponderosa's, I'd steal quick glances at my father. He'd eat quickly yet neatly. He had perfect table manners, using both knife and fork because we weren't allowed to eat with just the fork. "Use your knife," he commanded. "Don't speak with your mouth full," he barked at Daniel. I looked at the other families. There was another family sitting near us. The father, bald, bearded, tattooed and wearing a leather jacket, looked rough except for his eyes and the expression on his face when he looked down at his daughter, a girl around my age. His eyes were full of love and he smiled a smile that was only for her. I stared at this other family. The girl said something and her father laughed a loud raucous laughter that reached our table. I glanced at Dad but he seemed not to have heard. He was encased in his glass tomb. I don't recall him looking at me. He ate silently and moodily. Whatever he saw or thought, was unknown to us. Even so, once a month, where he couldn't escape behind the bedroom door or out the house and into the car, I tried to reach him.

"Dad?" I'd ask with trepidation.

"Mmm?"

"I got almost all A's on my report card."

"Good." A slight nod accompanied that, but he'd continue to eat and look down at his plate so I didn't try to engage him anymore until the following month where I might have said, "Dad, I made it on the swim team." "Good," he'd answer. Then the bill was paid and we walked out single file, back to the car, back to our silent house where Mom swept the kitchen vigorously as if she could sweep out the unhappiness.

"I don't remember those times as being so good," I told him. "It's like we're not talking about the same family. Don't you remember Ponderosa's, how you hardly talked to us?" A part of me was still scared of him, that he might once again fly into a temper and stalk off, leaving me with Savannah, bereft and unable to explain. "How do you remember it?"

"Well, your mother and I weren't really getting along so I suppose it must have affected you more than Daniel since you were older."

"It affected us both. I thought you hated me. You were always shouting at me and secluding yourself in your room." He nodded but didn't say the words I needed to hear: that he was so very sorry. "You know what the worst part is, Dad? I turned into a crazy female version of you." I felt my face distort with anger and bitterness. Part of me wanted to blame him for how my life had turned out. "I married Conrad because of you. I tried to marry your polar opposite."

"Good Lord," he exclaimed and a flash of anger flickered across his face. "That was surely a mistake." He laughed harshly. "That was your unfortunate choice. You can't blame me or anybody else for that."

He was right, of course, I had only myself to blame. I nodded morosely. Conrad, Savannah's father, was a mild-mannered man who seemed gentle and caring beyond belief. Harsh words were never spoken between us but it took me five years to learn that mild-mannered and gentle are easily disguised as non-confrontational and passive aggressive. Conrad would not venture near a discussion where there might be a disagreement and I had to quickly haul off the dress and don the pair of pants. I joked with my friends that I grew a twelve-inch dick while Conrad's shrank into a vagina. I became my father and Conrad retreated to the garden, spending hours with his hands buried in the soil or going to the park and sitting on a park bench talking to strangers. It was pathetic. There was no fight in him, no substance for me to stay in love. He lost his job at thirty-five, went on unemployment and stayed there, complaining that there wasn't anything out there for a man his age. It was pitiful and it got so that I was embarrassed to be around him and his hunched shoulders.

"How could I not see what a mistake it was?" I asked my father in bewilderment.

"Sometimes things are good for a time, like me and your mother," he

said matter-of-factly. "Good things come out of every bad situation," he looked down at Savannah, ruffled her hair and smiled. I looked away and out the window and saw that the sky had opened up and sheets of snow were coming down in torrents. Dad followed my gaze.

"There's no way we're walking out in that," he said. "We might as well order dessert and hope it passes."

Without looking at him, I said, "Dad, I never thanked you for helping me to get through that ordeal." I'd turned up at his house one night, a year ago, with Savannah, four suitcases and ten garbage bags with everything I could take with me. Dad had not said much, had not asked how long I was going to stay. He'd simply lifted the suitcases up the stairs and into the guest room. He had stood at the doorway of the bedroom waiting for me to speak but there seemed to be an understanding, almost an expectation that I'd turn up on his doorstep one day. I wanted to pour out my heart but I wasn't used to doing that with dad. He stared at me, unsure of what to say himself. "I read something once," I said to him then, my eyes open wide to keep the tears at bay, "from a book, a line from Madame Bovary that I'll never forget. It said, 'this man could teach you nothing: he knew nothing, he wished for nothing.' That's how I feel about Conrad." Dad's figure in the doorway shifted slightly. He was silent. "Is it okay for Savannah and I to stay? It won't be for long. I plan to immigrate to Canada."

"Stay as long as you want," he said.

I didn't tell Dad that I'd lost my temper and hit Conrad, that I'd stood before him like a rhino ready to charge and drew my hand back and open-hand slapped him across the face. He'd come home drunk and left the hose on after watering the plants. He'd also left the garage open and our bikes were stolen. He didn't seem to comprehend what I was trying to say as I screamed about the stolen bikes and the water bill that was to come. My hand left a red hand print on his cheek. The adrenaline rush that followed made me remember everything: how the grout on the bathroom tile needed scrubbing and the expression on his face – shock, remorse- as his head dropped to his chest and he said pitifully, "Sorry, Catherine." He was so drunk, I barely recognized my name when he said it.

I packed up that night, throwing things wildly into garbage bags. It

may have seemed to an outsider that I was impulsive but I'd thought about this many times, wondered where I'd go, and what dad would say if I turned up at his door like I had just done. I needed a man with some fight in him. Not too much, not too little. I had to leave Conrad. I didn't tell dad that I'd contemplated what might happen if one night, I waited for Conrad to become inebriated and then held a pillow over his face. I could have told him. He was well acquainted with rage and so I asked him what I'd wanted to ask for so long.

"What happened the night that you broke all of Mom's records?"

Dad's face registered surprise. "Your mother and I got in some quarrel over something. I can't remember that far back."

I couldn't believe it. How could he not realize it had changed everything? "Dad, remember how you told me once that you were in a hurricane and you'll never forget how the wind snarled and roared and how the trees bent right over like they were made from paper? How the rain sounded like bullets on the roof and then there was complete silence and stillness and you wanted to go outside but you knew it was the eye of the hurricane and that the crazy madness would start again? Remember you told me all that after a hurricane destroyed the roof?" He nodded. "Well that was how I felt being under that bed listening to you and mom. I covered my ears and squeezed my eyes shut so hard I got a headache, but it didn't hide the snarling and the roaring and the sound of things being thrown across the room. Then there was stillness for a second and then there was the sound of all those new records being broken and Mom screaming. I was only seven. I'll never forget it."

"Why were you under the bed?"

"I was in your room looking at your Playboy magazines and putting on mom's makeup when I heard you coming so I hid under the bed. Didn't you notice that I never went into your room after that?"

"Catherine, you have an unsettling way of remembering only bad things. No, I don't remember. Why would I want to remember something like that? As a matter of fact, if I were you, I'd stop focusing on things that happened in nineteen eighty something and focus on what's right here in front of you." Dad looked down pointedly at Savannah and stroked her head.

When I came to Canada, Dad hadn't said much except to ask if I was

sure I was making the right decision and to remember that his door was always open. I was determined to go north and now sitting in the Swiss Chalet, a swell of tears rose up within me and spilled out. It was too late to regret the move and too silly to continue blaming my father for marrying someone who was the opposite of him.

"I wish I'd never left," I said, my face distorting with the effort to keep from crying.

"You made the right decision to leave a bad marriage," dad said, as if Conrad was the reason for my tears that were erupting in the Swiss Chalet restaurant.

"I know that. You think I'm crying over Conrad?" I snorted with derision. "I'm crying because...I don't want you to leave. Savannah is going to miss you. I'm crying because I promise to never shout at Savannah again, especially for dumb reasons like when she mixes up 'b' and 'd.' I just get so angry and it consumes me. I erupt."

"I know, Catherine."

"But I won't do it anymore."

"I'm glad. It can't be easy for you, working and looking after Savannah by yourself. It can't be easy," he repeated softly.

"I hope Savannah has good memories of me," I said, "you know, when she's older."

He shrugged. "Why wouldn't she?" He handed me a napkin to dry my tears.

When we left the restaurant, Savannah was sleeping and my dad lifted her and held her close to his chest despite the snow and ice on the ground. He couldn't see well in front of him and he walked tentatively to the subway where we descended the stairs and into the warmth. Savannah's chubby arms were wrapped around dad's neck and she slept peacefully. I felt a lightness in my step and an unexpected euphoria lift my spirits. It mingled with the ache of loss: dad was leaving in two days. Savannah and I would be alone again. As we stepped into the light of the subway station where the roar of the subway coming in didn't wake Savannah, it occurred to me that the mellow man she knows as her grandfather, is not the same man I grew up with.

Peta-Gaye Nash *was born in Kingston, Jamaica, but has made Canada home for twenty years. I* Too hear the Drums *is her first short story collection published in 2010. Her work has appeared in several anthologies and she has written six children's books. Peta-Gaye won the 2015 Marty Awards for Emerging Literary Arts and in 2013 she received an honourable mention for the same award. A graduate of McMaster University, Peta-Gaye teaches English as a Second Language in Mississauga, Ontario, where she lives with her husband and four children.*

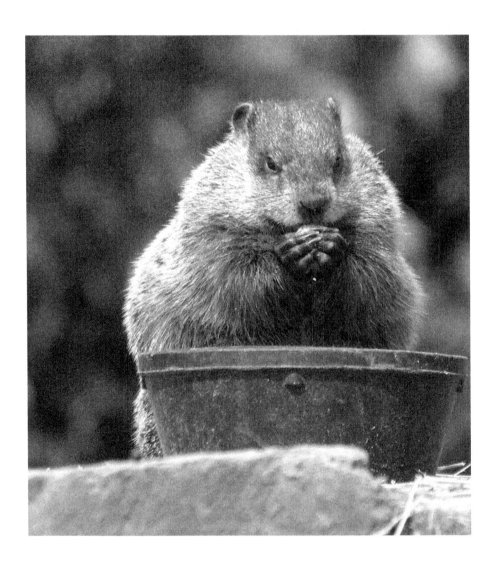

Lindsay W. Albert

HOMEWORK ASSIGNMENT

(With thanks and gratitude to the late Mrs. Harlander)

The homework assignment Mrs. Harlander gave to the second grade class was a routine one – write a two-page story. She could not have foreseen the life altering impact this assignment would have on one of her students who had a dark secret hidden within her.

The young seven-year-old girl went home at the end of the school day. After supper she began working on her homework assignment. With pencil and paper in hand, she stared at the blank page. She thought being an avid reader this assignment would be easy. At the blank page she continued to stare. She felt frustrated.

She gathered her pencil and paper and went downstairs to the basement to be with Tippy, her Collie/Terrier dog. A faithful friend in whom she could trust. Suddenly a noise upstairs startled them both. Tippy growled. The little girl's heart was pounding as her head filled with thoughts of who it could be. She sighed a deep breath of relief as Tippy's fringed tail began wagging and she heard her Father's familiar voice.

She thought about what had just happened and how frightened she'd felt. A feeling all too familiar to her. She put her pencil to the paper and watched her hand begin to move. Line after line the words just spilled out.

The next day she showed Mrs. Harlander her work. After reading the story, Mrs. Harlander looked the young girl in the eye "Well done, my dear, you're going to be a Writer one day."

From that day forward, writing was her healing release to cope with the fears and memories of abuse that tormented her.

As you've likely surmised, the little girl is me
It's through my writing, I've been set free

I NEVER MET YOU

(in loving memory of Ramona)

I'll always love you
Even though I never met you

You're a part of me
Even though I never met you

I mourn your death
Even though I never met you

I tend to your grave
Even though I never met you

You complete our family
Even though I never met you

You're my sister too
Even though I never met you

I miss you Ramona
Even though I never met you

I'll never forget you
Even though I never met you

You died an infant
Before I was born

This is why
I never met you

A LIFE TRANSFORMED

(Dedicated to Leslie B.)

Filled with darkness was my world when we first met
You opened the window allowing light to shine in

Walking alongside me countless are the times
you went above and beyond what others would have done

You nurtured a trust which grew and grew
There when I needed you yet gave me my space

With your caring, compassion and a listening ear
shared your knowledge to help me cope in new ways

A healing path of discovery and recovery we blazed
uncovering strength, transmuting pain into resilience

Now when days are cloudy
I can weather the Storm

Some days you may wonder if a positive difference you make
I, for one, know you do, so please don't forget this

You transformed my life
you empowered me

you shifted my darkness
helped me work through the pain

Through you I discovered
a new way to see me

Now, I know in my heart
my life is worth living

I believe in myself
and what I can do

Dreams that before
I dared not to seek

now I go after them
with my heart and soul to complete

AA 35

(dedicated with love to my brother)

Long ago was a time
when my brother did drink
till a brush with death
did make him rethink

To keep on living
he had to find a new way
and he found the rooms
of a group called AA

To himself and the Programme
he did commit
Stayed true to both
and the booze he quit

This new road was hard
in meetings he'd sit
took it "one day at a time"
practised "easy does it"

Sober days of one,
a week, month, a year
his group and he celebrated
with chip, medallion and cheer

Steps 1 through 12
he continues to apply
Friends, meetings and slogans
have helped him stay dry

His perseverance proves
what a person can achieve
so don't give up and
in yourself do believe

My brother, I love you
from deep in my heart
had you died that night
I'd have been torn apart

Instead, we're here to honour
your Sober Year 35
Congratulations with my love
a big hug and high five!

Lindsay W. Albert *has participated at poetry events in the GTA. Her poems have been published in four anthologies:* The Courtneypark Connection *(2013);* The Labour of Love *(2013); and* The Literary Connection, Volume I *(2014);* The Literary Connection, Volume II 'My Canada' *(2015). Lindsay writes about life, loss and grief conveying hope, healing and insight to her audience to inspire them to discover their inner strength as they travel their own journey of life.*

Joseth Reid-Tulloch

MEMORIES OF MY CHILDHOOD

My fondest memories of my childhood are those spent with my grandmother, Queenie, my brother Ian, and my great-grandmother, Frances Laumann, affectionately called "Nana."

We lived in a one room apartment in Kingston, Jamaica, but these were the happiest days of my young life. It was at this time that I learned what it meant to belong to a family. I was cared for and loved and I felt very secure.

I can remember Grandma washing my hair (what an ordeal that was!), and oiling it and then brushing it to fluffy softness. She would then part it into two perfect sections which she would braid until it reached past my cheeks to my neck. Then the *grande finale*: two luxurious satin bows on either sides!

I can remember going to school in navy blue and plaid uniforms ironed until the pleats were razor sharp, and coming home to the smell of some delicious menu simmering on the coal pot outside.

In the mornings we would wake up to the smell of fried plantains and eggs or cornmeal porridge cooked deliciously with cinnamon, nutmeg and condensed milk along with soft hard-dough bread and butter. This was often served with hot chocolate "tea" - the kind you grate and boil with cinnamon leaves and sweeten with coconut milk.

Early morning would bring with it the street sounds. Vendors selling their produce and services would pass through the streets, hustling to make their sales before the blazing morning sun came out in all its glory.

There was the Callaloo lady, whose cries of "Fresh Callaloooo!" could be heard far and wide. I always marvelled at how she could walk so fast and yet so gracefully while balancing her laden basket of greens on her head.

The "clip-clop" of the milkman's horse drawn cart could be heard as his piercing whistle summoned customers to their gates, containers in hand, ready and waiting for their orders to be measured and poured.

Not to be out-done was the coal man who was very noisy as he shouted

commands to his over-worked mule, while the crack of the whip stung the resistant animal. Even as a child I knew the words he shouted were not good ones and were not to be heard coming from my lips.

The bread cart came by much quieter and you had to know the time it would pass or you would miss it. Sometimes my brother and I would look out for the cart and alert Grandma.

There was a host of other vendors who would pass by during the course of the week, including the "fish man," the ice truck, the "soldering man" if you had any pots (cooking or chamber) to repair, and of course, the "umbrella repair" man.

There was so much respect for all these vendors who were essentially providing services for the community. The Rasta man, dressed in his robes, sandals and turban and selling his brooms, was respected for his spirituality and his "entrepreneurship." We needed brooms to keep our homes and yards clean so he was definitely considered as providing an "essential" service.

They say that as you get older, your long term memory becomes more acute. These memories are surprisingly vivid in my mind after so many years. In those days we did not have cameras and iPhones at our fingertips to record our memories and going to a photo studio was expensive. Sadly, the only picture of my grandma has been lost over time. But she will always be in my memory.

I lived with my grandmother until the age of nine when I was sent to England to live with my paternal grandfather. Those memories added a new dimension to my life. And that's another story.

Joseth Reid-Tulloch is the author of two children's books, Manu's Special Day *and* Today I Made A Friend. *She is a graduate of Mico Teacher's College (now Mico University College), and taught at the primary and secondary levels before migrating to Canada. She is also a graduate of George Brown College Early Childhood Education Program. She presently works as an E.C.E and enjoys writing, travelling, reading and doing floral arrangements.*

FEDERALLY EXPRESSED

I have all this Love inside of me
Tucked neatly away
A packaged offering

The string is tied in a bow,
Taped ends
Serious creases

I've mailed it
All over the world
And it keeps coming back

A few rips and tears
A smudged return address
Still intact

Wisdom would dictate
That "return to sender"
Is only incentive for a courier next time

TENDER BE THE HEART THAT GUIDES

Teachers bestow knowledge
Saints bestow morals
God bestows a Soul
nestled gently in a heart
awakened by Wisdom

GOD'S PROMISE

A child's promise
is an unbreakable bond
pinky swears and blood oaths

In the real world
a promise can be so empty
disappointing bitterness and tears

In the spiritual world
the promise of salvation
becomes the Food of Life

GOD WAS WISE

Spent countless hours
wanting you
spent countless days
missing you
spent darkest nights
needing you

God was wise

showing me that
wanting
missing
needing
are illusions
and being
without
is preferable
to hindering
that revelation

PIGEON

Wrenched my heart
no one paused to look
insignificant
a small body
on the road
a bloody beak
lifeless

They mate for life
somewhere
there is another little body
wondering why she is left
cold and alone
tonight

to take notice
of little souls
bleeds the heart
each time
so there is not
much left
for me
anymore

Am much emptier
than when I first
came here
but never lost
being able to spy
the little souls
who were left
on the road

UPON MY FATHER'S GRAVE

Nine years
to the day
in my darkest hour

I laid my poem
upon your grave
and read it aloud

I planted the page
in a cup reserved for flowers
so that it may grow roots

The roots you gave me
the roots that saved me
the roots I honour and cherish

YOU DIDN'T KNOW

You didn't know
the avalanche you created
that poured the wine of words

The savoured drink of saviours
for the drowning soul
within my breast

You didn't know
you will never know
…as it should be

Susan Munro is a Toronto-based healer and esoteric poet. Schooled for over 30 years in Esotericism, she combines her knowledge of Spirit with her undying dedication to helping people feel better. She practices Reflexology, Acupressure, Reiki and Essential Oils and makes it affordable by applying a sliding scale for lower income families.

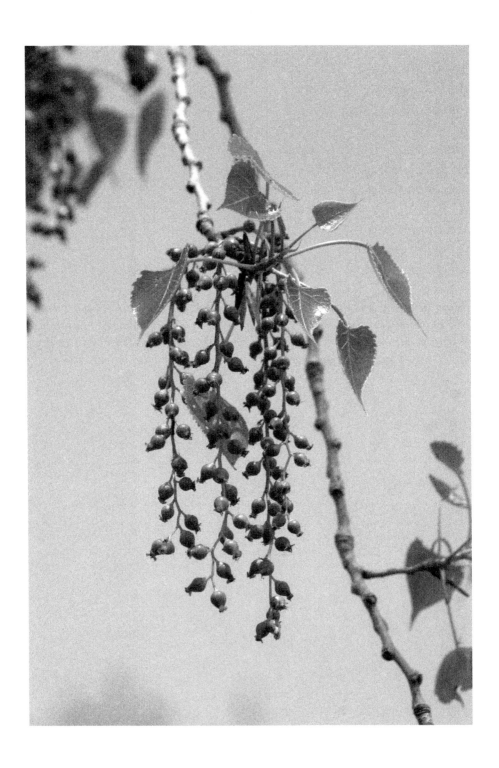

Corrina Fleming Leblond

HAUNTED

Clutching the edges of the mirror I screamed in silence.
I see you, I know you are there! Show yourself!
Grief welled up inside as my swollen heart constricted; expelling ache in
one single tear that sped down my crimson cheek.
Stale cigarette smoke lingered in the hallway; yes
she was here all right! Her soft words murmured and echoed
off the walls as spiders hugged their cozy winter corners.

The air parted slightly and whispered, "I love you, and I'll always be
with you."
I know she is here, I hear her in my own voice as I whimper
I love you mummy, mummy, mummy
as I always did sing out in her praise.

Remembering how she held back her last tears as did I on that day
Moments that I curse as it was so unnatural
full knowing there would be no more hugs and hellos.
The good bye was loud as it screamed
in the absence of the tears that were forced
so very far back…

With a lump in my throat
I winced out that one last fake smile.
I turned away choking on my dry thick sorrow,
trying as best I could to swallow the loss.

My throat was closing in; I couldn't breathe out
one last turn back over my shoulder.
My eyes glazed over as my heart filled with tears
I never thought I'd bear witness
to my first, my last and my final goodbye.

TODAY I REMEMBERED YOU

I thought I saw you today, rugged good looks
same black jacket as you always carried
yourself in so well; even those same short
worn cowboy boots that made you look so in style.

I stretched my neck as far as I could see
for just one more glimpse
as I watched your face light up
with a smile; that too was familiar,

same face, same eyes, same smile
I couldn't hear what you were saying
yet I could not take my eyes off you
at risk of someone seeing me stare

I wondered if they would also see the longing
in my eyes, excited by the familiarity that accompanied
this moment, nothing more than this moment
Remembrance, hope, wishful thinking and maybe even spirituality

Your skin dark
the same as it always was
with just a little too much of the summer's sun
sun-kissed just a few hours too long

Youth had not left you so long ago
The twinkle in your eyes exact
As your lips spoke more words I could not hear
I longed to get closer
I didn't want to leave but I knew I could not stay

I watched a few more minutes, your body leaned forward
a silent whisper in your wife's ear, maybe it was your wife
That was not clear to me, I'm guessing
Everything about you screamed "it's him"

You were of the same age as me now
inside my heart knew there was no way
but I could just not stop looking, wishing
Maybe I just needed that moment with you

A long time has passed since
I last saw your face; a lifetime ago
Time surely has a way of getting away from us
In no time I'm sure I will see you again

Not too soon I hope
Somehow I felt heaven touched me today
I remembered you and with this memory
And the love I longed to see in your face

No matter how much time a child has with a parent
They always love their parent
And if this lifetime does not satisfy that need
the need lives on

Today I remembered you
And as that love was cut short
in this life, I look forward
to loving you longer in the next

Corrina Fleming Leblond is a social worker with a passion for people, writing, and nature. A strong advocate for women, Corrina works as a Program Coordinator for a not-for-profit helping abused, low income women gain access to training and employment opportunities.

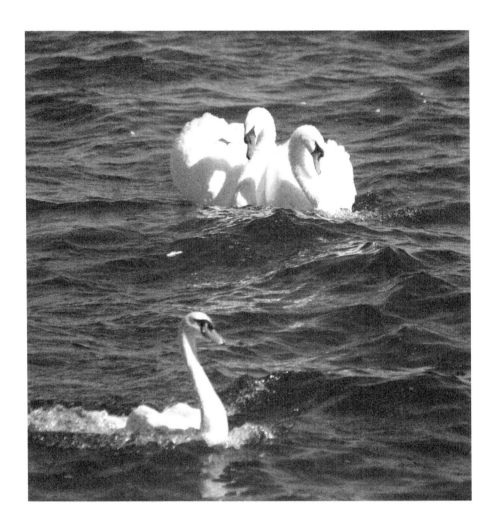

Merridy Cox

FERRY TO VANCOUVER ISLAND

Anticipation for the voyage
In the expectant lines to the dock,
Vehicles of all sorts occupied
With people of all sorts, all going
Somewhere over there—to the island.

Somehow, the riff-raff of vehicles
Is ordered into lines, finally
Pushing forward and over the ramp,
The hollow-sounding, moving, way on
To the swaying interior space.

My car is now tightly entombed
And sits nosing the next vehicle
In the dark level assigned to it,
And then, deep down, the ferry's engine
Starts, rumbles, vibrates, heaves—underway.

To remove myself from visions of
Crossing the flow of the River Styx,
I mount the metal stairs, swaying,
As the ferry ploughs through cresting waves,
And find the horizon at the rail.

There is a thrill to the ferry ride.
Moving away from shore on water
That also moves somehow towards and
Away and up and down and across,
I keep my eye on the horizon.

A momentary glimpse of dolphin
Brings me into the living seascape;
For a while, I watch the waves for more.
Gulls follow the ferry, easily
Gliding at their favoured positions.

Then I look up, and there in the sky
Is an eagle soaring loftily
Upward on a warm column of air.
My heart catches a beat until there,
I see another eagle above.

Eagle above eagle, more above,
Circling the air current, rising
Into the furthest high pinnacle
Of sky. Each eagle like a moment
Of grace, the hundred are breath-catching.

The engine rumbling, the dark levels
Of lines of cars, the waves, the dolphin
No matter not, insignificant
When the heart is lifting to a sky
Full of soaring eagles, by and bye.

Merridy Cox *has published poems and photographs in* The Literary Connection: Volumes I and II. *Her photographs and a poem also feature in an upcoming picture book,* The Swan Family's Summer. *Merridy is a technical writer, editor, and indexer in Ontario. Follow her blog,* http://www.englishmanual.wordpress.com.

Jason (Wei) Chee-Hing

NEVER FORGOTTEN IN THE FULLNESS OF TIME

This I know
I have lived more years
Than I have left
The sands of time
Have shifted past my halfway mark.

The early years
Now mere glimpses of memories
Like fleeting moments in time.

Days are now counted
As I live each day
Savour each moment
Feed my senses
And nourish my soul.

The grains of sand
Inexorably fall in nature's hour glass
But before that last grain falls
And I meet my Maker
I know this.

I want to live those moments again
As often as I can
Those very simple things
That have moved my soul.

I want to sit on a lonely beach
And watch the sun rise
As it dispels the darkness
And casts a golden hue on the waters.

I want to gaze at the full moon
And marvel at her beauty and serenity
As she hangs high in the night sky.

I want to sit beside a pond
Still and silent
And watch the dragonflies
Skim the water
And the snapping turtles
Bask lazily on the decaying log
Listen to bird song
And the croaking of frogs.

I want to watch the fireflies dance
Like glittering specks of stardust
On a hot, windless summer night.

I want to stand in the summer rain
As it beats against my naked body
And after the deluge
Smell the earth, the grass, the air
As it overwhelms my senses.

I want to hear again and again
The laughter of my daughters
As they tell me their hopes and dreams.

For I have lived a complicated life
Faced life's disappointments
But I have my joys.

The joy of my children
The joy in their love
The joy in knowing
that my essence lives on in them
Long after that final grain falls
And I am but a faint echo in time.

And the joy
of knowing you my love
Of the things we shared
The joys and the sorrows
And above all my love
That you will never forget me
in the fullness of time.

BLUE MOON

She lights up the evening sky
Bright orange
Full and ripe
Fiery and round
Pregnant and luminescent.

Slowly rising
Against a darkening sky
As night falls
She casts a silvery light
Through my window.

My lover
Do you gaze at the same moon?
Does she remind you of me?
This blue moon.

You have been gone far too long
Your distant wanderings
Make my heart ache.

Let's once again
Walk along the stream
Hear the gurgling waters
And watch the river turtles
As they bask lazily on the log.

Look into my eyes
Like you used to
Hold me tightly
As I feel your hot breath.

Let your hands wander over my soft flesh
Over my breasts
Between my thighs
And hear my sighs.

Each caress worth a hundred memories.
Let's lie on the soft dewy grass
Under this magical moonlight.

Look at the blue moon
My lover
And you will look into my heart.

PARADISE

Cool breezes blow in from the azure waters
Brushing against my soft skin
The water gently caresses my body
As I lay in the sand.

The sounds of the surf
Is as rhythmic as a lullaby.

The sun slowly rises above the horizon
Casting a golden glow on the water
She rises like a phoenix
Heralding a new day
Dawn's first light
Holding the promise of new beginnings.

The shimmering waters
Are like a hypnotic trance
Playing with my mind
My innermost thoughts.

Images of past events abound
Like a kaleidoscope of psychedelic colours
Thoughts collide
Like crashing waves on a lonely beach.

How I wish you were here.

Jason (Wei) Chee-Hing grew up in the inner-city neighbourhoods of Toronto. He has been writing for many years and will soon be publishing his first collection of poetry.

Danielle Lobo

MONDAY AFTERNOON SPIRIT HUNT

Faylin and I sat at the dinner table with our arts and crafts supplies. She was intent on gluing all the edges of her mini-cardboard box. I took little artistic liberty with mine, haphazardly constructing my box, enjoying the feel of wet glue and sparkles on my hands. I smiled at the intricacy of hers, she was six-years-old and I was twenty-four, and it was my box that looked like the child's creation.

"You know, Evelyn, I can see ghosts," she said after a period of silence. I was surprised by her confession. I baby-sat her since she was an infant and she had never hinted at this before. Me being here now was a random visit to help her mom who was taking her ex-husband to court for custody. I assessed the veracity of what Faylin was telling me. I could tell she was being truthful because she hesitated after telling me, this as if she had blurted out a deep secret.

"Really Faylin? You know, I can talk to spirits too, but I can't see them."

She looked at me in disbelief, surprised that not only did I believe her; I knew what she was talking about.

"You talk to them?" she asked.

"Yes. You can talk to them too. To only the nice ones if you want. I forgot for a while how to do it, but then I taught myself to remember, to remember how to listen to them."

"Oh. Umm. When I see them, I don't like it."

"What or who have you seen?" I ask with genuine curiosity. I believe that many infants and young children see spirits, but most children by the age of six are socialized out of these senses.

"John saw one outside his bedroom window at night, then I saw it too. We both got scared. He talks to us but I don't like it."

She pauses in obvious anxiety about the subject.

I know it is true because her brother John has autism. His mom told me that he stopped sleeping in his bedroom and would wake up in the middle of the night crying and scared. He can't speak so she hasn't been

able to find out what's bothering him.

"The more you are scared of spirits, the more they make you scared. You can just tell it to go away if you don't like it. And they are not all bad. Most are okay."

She listens and processes this. "I also see a little spirit. He is old with a grey beard and comes quickly into the kitchen and then disappears. He's this big." She uses her hands to show a height of about one foot.

"Oh I know about little spirits. They are the kontomblé spirits as the Dagare people in West Africa call them. They are little grandmothers and grandfathers. I have heard from some old people I know that they appear to young children to show them a secret from the spirit realm. I don't know what happens after but I think it's good. Is he nice to you? Do you ever talk to him?"

"He's okay, I guess. He comes out of nowhere and is always running and then goes away underneath the bottom of cupboards or the floor. Every time, my brother or mom comes into the room, he runs away and I can't find him again."

I was surprised, but also understood why this kontomblé chose her. Faylin was special and had a sense of knowing beyond her years.

"Okay, you know what I am going to show you my own surprise. Let's go outside."

I put down my glitter tube. She looked excited and I shared her sense of adventure. She lived in a townhouse complex and we weren't close to a natural forest, which would have been the ideal location. So instead we strolled down the sidewalk.

"Look for any stone. A pretty one. Big or small. One that catches your attention. Pick it up with your left hand and ask it if you can take it with you to protect you from spirits."

Her eyes widened and she became attentive to each step looking around for stones. She saw three or four stones and each one she picked up and then put it back down. I waited patiently as we walked further. She found a stone she liked. It is so easy to be with children. They can easily perceive the sentience of everything.

"Put it to your heart and tell me if it is right."

She put her arm across her chest with a tiny fist around the stone meeting her heart.

"Yes. This stone is good." She smiled.

"Okay. Let's go back inside. We are going to walk through every room of your home and you tell me if you see anything. I will be with you."

She nodded. We walked back inside. I turned off all the lights in the home and we walked through each room. I was attentive to any sound or feeling around me. The stone in her left hand, we clasped our right hands as we walked in silence; glancing at each other as we moved. Even I was a bit nervous. When we arrived in the kitchen, she squealed. I whispered to her asking what she saw. She shushed me and tugged my hand out of the kitchen. She had seen the faint outline of the kontomblé spirit she spoke of before. "Let's go please, Evelyn," she pleaded.

"It's okay, Faylin. We'll do something else."

We finished our quasi spirit quest and went to her room to play her electric piano. She smiled and played as if nothing happened. I remembered what it was like to be so fearful at her age. I wished I could see the kontomblé. It only took me 18 years but I would listen.

Danielle Lobo *has a traditional healing shamanic practice. She is a licensed small boat captain and considers herself a water spirit at heart. This past year, she spent six months being "initiated by the water spirits" on the Atlantic Ocean sailing on a replica barque ship. She loves discovering with youth, side-by-side, the magic that exists on Mother Earth.*

Phyllis Kwan

PROMISE MADE

I must plan a trip to Italy lest I forget a promise I made years ago. Promises made should be kept. I promised to go to Padua to visit the shrine of Saint Anthony of Padua, my patron saint.

This story is my true story and started many years ago when I was a little girl growing up in Trinidad. At the age of about 10 years old, I had amassed a little fortune of $40.00. I used to do chores for my mother and she would pay me 25 cents for each of my completed chores and I also received a weekly allowance of 25 cents. Saving $40.00 was quite a feat for me and one I was most proud of. It took me over two years to accumulate that amount of money.

I hid my hoard of cash in a little brown leather pouch which I put in my closet on a special shelf I reserved for treasures and precious items only. I kept my pretty little patent leather purse with the gold bow there, as well as my favourite doll, and my leather money pouch.

One day I went to my room to count my money as I was wont to do a couple of times a week. To my horror, my brown leather pouch was missing and it was nowhere to be found. I searched high and low in my room. I turned over my mattress, checked under the pillows, checked the floor under my bed and everywhere else I could think of. I questioned all my family members and after a couple of hours searching frantically and fruitlessly, I began to wail. I cried with deep body-wracking sobs until my elder sisters helped me look for a while. But after finding nothing, everyone in my family gave up and became oblivious to me and my pain. To make matters worse, Mom and Dad refused to just give me $40 in cash to reimburse me for my grave loss. They actually chided me for being careless and losing my money. And that made me cry even more.

Then, I remembered a Book of Saints I had recently read. In that book there was a patron saint for just about every cause in life, or so it seemed to me. I quickly ran and got that book from our bookshelves. I thumbed through it, and yes … there it was … Saint Christopher was

the patron saint of all travelers, Saint Francis of Assisi was the patron saint of all animals, and then I found it—Saint Anthony of Padua, who was the patron saint of lost things.

I quickly got on my knees in my bedroom, made the sign of the cross and started praying. I said, "Dear Saint Anthony, you don't know me, but my name is Phyllis. I have lost my brown leather pouch with all of my life's savings. I worked hard for my money doing chores for mom, and I saved every 25 cents I got for my weekly allowance for over two years. Please help me find my pouch, and I promise I will be a good girl." All the while I was praying, I was also crying. I was so tired after my prayer that I lay down on the floor beside my closet and fell fast asleep.

The next thing I recall is waking up and finding myself on the main floor of our building, in the huge storage room at the back of our store. I stood confused, surrounded by boxes and crates, and then I moved to the center of the room and pushed aside some boxes and there was my leather pouch on the floor. I could not believe my eyes as I picked it up. I could not remember how I got there. Neither could I remember walking downstairs to the main floor from my bedroom on the second floor, nor how I knew to push those empty boxes aside to discover my pouch on the floor. I realized then it was a little miracle performed on my behalf by Saint Anthony. Thank you, Saint Anthony, for returning my lost pouch to me!

The last and most recent time I called upon Saint Anthony was in 2012. My best friend's daughter got married on a lovely Saturday in September 2012. The wedding was that of a lovely young Greek woman marrying a very nice young Portuguese man, and the reception promised to be a fabulous affair. Of course, I dressed in my finery, all prepared to party. The celebration was very festive, with fabulous food and wonderful music. My husband and I danced all night with happiness for the young couple. We left the wedding after midnight after hugging and saying goodbye to our hosts.

We got home pretty close to 1 am and while I was undressing for bed, I realized my diamond bracelet was missing. I was horrified. That particular bracelet meant a lot to me as it was a gift from my father's estate (when he died in 2006) and I treasured it enormously. My

husband fell asleep quickly. He was exhausted after dancing all night, and I quickly got up and changed into a sweater and jeans. I didn't say a word to anyone, and let myself quietly out of the house, jumped into the car and drove about 30 kilometers back up to the banquet hall. At this point, I was praying feverishly to Saint Anthony, patron saint of lost things. As I pulled into the parking lot, I saw my girlfriend Helen, just preparing to leave. She asked me why I had returned, and I told her my sad plight. Even though she must have been exhausted, my dear friend helped me look for my bracelet.

We went to speak to the manager who was directing the cleaning staff, and told him of my predicament. He commiserated with me and helped us look in the ballroom, and around the dining room where I was seated. Helen and I checked the ladies' bathroom and we searched the entire ballroom, most especially the dance floor with no luck. It was close to 3 a.m. at this time, and realizing that Helen was exhausted, I told her to leave. I told her I would take one last look and then leave as well.

I was almost resigned to having lost my bracelet permanently. After looking one more time, I left and as I walked out of the building I decided to retrace my steps to where I had parked my car. There was only one other car parked in the entire parking lot. It was a black BMW X5, and as I started walking toward it, I saw the manager exiting the building along with the bartender whom he was giving a ride home.

The manager approached his car and as he drew close to his car, he walked around it to the back to load items in his trunk. Then I saw him bend over and pick up a shiny strand from the asphalt. He held it high for me to see. I knew at that moment that he had found my diamond bracelet.

Earlier in the evening, when we arrived at the reception, we had parked my Honda CRV next to his BMW in the parking lot. And when we left the wedding, we went to load our gifts into the trunk of my CRV. I do recall bumping the trunk door with my hand or brushing against it, and apparently that was when the clasp on my bracelet became undone. I did not notice at all when my bracelet fell off and onto the ground beside my car.

Joyfully, I ran the last few steps towards the manager, and gave him a

heartfelt hug and a kiss on the cheek. He was a handsome younger man in his late thirties or early forties and he was impeccably and elegantly dressed. Also, his cologne was very pleasant when I kissed him, and he showed some surprise at my spontaneous gesture. He and the bartender were both smiling from ear-to-ear; they were so happy for me. I knew in that moment that Saint Anthony had helped me once again. The evening had ended on a very happy note.

That night was almost surreal. I drove home in the wee hours of the morning, secure and content in the knowledge that I am blessed. I have God's ear through His angels and saints. Finding my diamond bracelet was another small miracle for which I give thanks and praise to God.

That is why, lest I forget, I have to keep my promise to Saint Anthony and to God, our Heavenly Father, to make a trip to Padua in Italy. There I will visit the shrine where Saint Anthony is buried and pay my respects and give homage to my patron saint. Promises made should always be kept.

Phyllis Kwan is an award-winning human resource specialist who switched careers to run a successful family-owned drycleaning business. Her passion for writing stories and poetry went from pastime to serious writing and in 2016 she published her first book, a collection of poems entitled Poetic Ballets of My Mind.

Janine Georgiou-Zeck

NOW DIVIDED

Another sip
Your voice
Your walking through the hall
Drifting by

A breath
Another thought
Your hand is in mine
But it's a lie

Sinking feeling
Falling into the now
I miss so much
Wishing the clock could turn back
Somehow

A sudden gasp
It's real
This moment without you

You haunt me

Embedded in my memory
Are the habits of us
Our time
Our path

Now divided

AGELESS

It is
An entity
That is born
In a glance
A touch

It is
A beam
From ones' energy to another

It is
free
Given and received
It wraps you up
And warms you

It is
A portal
For time travellers
It carries hearts
Through the ages

It is the ultimate memory
In loss

It remains
Ageless

IMMUNITY

Tears,
Gut wrenching cry,
Numbness,
Exhaustion,
Pure pain of love rejected

Abandon
Betrayal
That which pierces the innocent heart
Cannot be undone

For it is as a virus
If one survives
One builds a little more

Immunity

Janine Georgiou-Zeck is an artist educator in York Region Ontario, the mother of three, and founder of Janine's Art School. Loves to create children's books and write poetry. www.jzartstudio.wixsite.com/kid-art-classes, email jzartstudio@gmail.com.

Pencil sketch by Shirley Aguinaldo

Shirley Aguinaldo

SUFFER THE LITTLE CHILDREN...

A little girl, lost and alone in the streets of 19th century London, had no one to care for her. With straggly hair and dirty clothes, this little orphan's only other option was to reside in the horrible conditions of a state-run workhouse where she would have undoubtedly suffered harsh treatment.

A gentleman could not help but notice the little ragamuffin, and extended his hand to her. His kindly face seemed to belie the fact that he was a former criminal who spent his youth defying his parents, stealing, drinking and gambling. Despite those days being long behind him, he still had no money nor any means of support; yet he would feed, clothe and educate this young waif, just as he had done with thousands of other children who passed through the orphanages he founded. He would do this without ever asking financial support of anyone. Who was this man, and how did he do this? His name was George Müller, and he did it on faith alone.

Perhaps you've heard the well-documented true story of the time there was no more food nor money in the orphan house. Still, Müller sat 300 children at the breakfast tables, prayed as usual and expected an answer. It came immediately. The baker knocked on the door and donated bread that he'd baked early that morning because he somehow felt the orphanage needed it. Following that, the milkman's cart broke down in front of their door, and rather than have the milk spoil while he repaired the wheel, he gave the milk to the children. There was enough for all.

The most remarkable thing about this story is that it is not unique. In fact, occurrences such as this were the norm where Müller's orphanages were concerned. Unrequested donations *always* came when needed, often at the last moment. Coincidental? Not according to Müller, who believed wholeheartedly in the power of prayer.

By not shrinking from opportunities where faith is put to the test, it was strengthened to the point where he depended upon God alone

to provide the needs of the 10,000 children that he housed over a span of 60 years. He never went into debt, and no child in his care ever missed a meal. It matters not what anyone's concept of God is, nor how limited our understanding may be, the facts cannot be denied that his accomplishments were nothing short of amazing.

Religion, with its rituals, need not have anything to do with it. Science and spirituality are not worlds apart as it may seem. It is quite possible that Müller inadvertently set in motion the law of attraction that quantum physicists say is one strand in a complex tapestry of how the universe operates. Thought is energy that creates our reality, and quantum entanglement shows that everyone is inextricably woven together. Understanding this, and using it positively to better the lives of those around us, would yield the same results as selflessly praying while faithfully expecting answers from a higher power.

Perhaps George Müller was not an extraordinary person. Maybe he was simply a person who made a decision to allow extraordinary things to happen through him. This is a choice we can all make. But to the little girl in the street who took his hand, and the thousands like her, "Daddy Müller" was every bit a saviour.

Shirley Aguinaldo is a graphic designer, writer and illustrator. She designs a variety of material including advertisements, brochures and books. Her digital illustrations have appeared in Peter Jailall's book STOP! STOP! Don't Be a Bully. *She has also written and illustrated a children's book entitled* Indoor Cats.

Nadia Tretikov

WHEEL OF LIFE

Faster, faster the wheel turns around –
 counting.
The happiness faints away.
I am old and sick.
I wonder—
Which day of my life would I like to bring back?

The day when my son was born was the happiest.
For sure the day when I met my wife.
Or maybe the day I was sharply awakened
By the mourning dove?

I remember that day so vividly—
There was a stranger
 who asked me to help him
 with his broken car.
I grabbed all my tools and we spent a day
And we fixed it
And I felt myself saved.

What else could I now hold on to?
Nothing left from those happy days.
Dull and dreary is my life
The insidious wheel of life
 keeps turning – counting.
And I drag myself
 sluggishly
 from way behind.

AM I RIGHT?

Through the thinning mists and dark-grey cloud
Twinkled bright little stars
I was wondering –
Was that sunlight
 shattered into pieces
like dreams in the hustle of life?
Was I right?
I peered closer and
 all of a sudden
 was dazzled by bright light.
I was blinded and became fearful
I did not see the source of excitement.
Did I witness a fallen star?

Bewildered, confused, yet strangely
Enlightenment dawned
I swung up to the Spirit of Light
Was thrilled and amazed
To be gifted
 with the joy of life.

CHILD'S LIVING WORLD

Where are you, my little Sunbeam?
Your brow forever a bright sunny day?
What does your soul bear today?
Reflecting the deep blue sky?
The freedom of open seas?
Purity of sandy white beaches?
Ease that aligns with
the Great Buddha's call?
Keep dancing, my Girl!
With the seagulls and breeze
Explore the world!
Sing a song big with love,
The child's magical living world!

Painting by Nadia Tretikov

A DIALOGUE WITH SELF

Did you ever have a dream that dazzled like lightning?
What dreams do you talk of? I have bills to pay!
Anyway, tell me.
Don't know. Maybe there is one, but I have no time for that crap.
Have you ever tried to fly?
In an airplane?! Many times.
I meant in your dreams.
Do you sing in wild abandon?
No. What will the neighbours think?
Can you dance?
Where is the music?
I am silent. I don't lose HOPE...
I am sad. I feel lost.
Don't lose FAITH.
Go back to your memories—its only a step back
From the cage of confusion
And the muddle of a cluttered mind.
Open your heart, give me freedom...
I don't understand what you are talking about...
Maybe, today you will notice and remember? LOVE is the guide.
Maybe...I will make the effort.

WILD DREAMS GONE

Do you remember those days of wild dreams?
When the whole world was a great fairy tale?
Each day was a new adventure
And friends were more important
 than your family
 on Thanksgiving Day?
Those happy days are over
You are old and sick and obese.
There are more doctors' prescriptions
 than calls from old pals.

All is lost – joy and laughter
Sense of life – wife and kids
You sit like a stupid old bastard
All alone, sick at heart. Sick.

THE GOLDEN TREE

I march on the road to sorrow
Every step revives old memories
No matter how hard I try to stay them
I march on
And nothing can stop me
 from slipping back.

Then the rain like a good shepherd
Stops the herd from sliding downhill.
I found shelter
 under the big golden tree.

Overwhelmed by the sudden change
I closed my eyes and fell asleep.
Sunny days, friends, laughter
Flood my unconscious
I am not marching.
I am standing still.
Love like an invisible barrier
Shields me from hard reality of life.
Past memories fade
 and happiness
 fills my heart –
with a new golden tree.

LOST

I followed the path, then made a turn.
Where am I? – I ask myself
The shadows around me are
 pushing me down. Halt!
Turn around – behold the emptiness
and the wall of unbreakable thoughts.
I am trying to find the way out of this.
Not a sign or a glimpse. Lost!
I am looking around for somebody
 to give me a hand. No one.
I sit on the ground – Emptiness
 and the horrors of my own thoughts
I scream out. Nobody!
Only shadows surround me.
I whisper into the nothingness: Please?!

JUNKYARD, 2005

He slowly, timorously stepped inside his parents' house.
"Why did you come? I didn't call. I didn't expect you to," said mother to son.

He shuffled his feet, tears running down his cheeks. "I am sorry, Mom. I forgot... I forgot where my home is. I lost it. I searched. I was looking for it everywhere. I crossed the world from side to side. I got tired."

Mother sighed heavily: "That's not where to look for it, not there... Where does your heart belong?"

"My heart is drained and depleted from looking for it..."

"What is it you are looking for?"

"I don't know now. Excitement? Exceptional beauty? Adoration? Delight?"

"Take a seat," Mother said softly. "Sit," she said one more time, pointing to the chair.

The son weakly sank onto the floor. He had not enough strength to reach the chair by the table in the middle of the room. Mother got down on the floor next to him and leaned against him with her shoulder.

"We don't choose our fate. It chooses us, but that's how we treat it defines the result. What seeds did you sow in your life? What did you plant? What did you harvest? Your seeds are scattered all over the world. Who watered them? Who pulled the weeds? Who covered them from the early frost? So, they all shriveled. Your heart became empty and infertile. Nothing warms it. Here you are sitting on the floor now, but your happiness is blown away and spread out all over the world. How do you collect it?"

The son blindly stared down at the floor. He couldn't comprehend her words. It seemed like idle chatter to him.

"Why have you come here?!"

"Don't know. I have nowhere else to go."

"Where is your family?"

"Which one?"

Mother sighed again. "Go to sleep. I'll make you the bed in your old place. Do you remember, you liked to sleep by the window?"

He shrugged. "What's the difference?" Walking quietly on a soft carpet, Mother was fussing around. He collapsed on the bed made ready for him as he was in his clothes, and soon fell asleep.

He was awakened by a rude loud male voice scolding him with a spate of obscene swearing: "Hey, get up! Enough lazing out here! Couldn't you find a place somewhere else?"

He woke up as quickly as he had dosed off.

He found himself lying in the ditch at the edge of the city junkyard. He couldn't remember how he got there. His Mother's words were still echoing in his ears: "Oh, Sonny, where are you?"

The surrounding filthiness: waste, dregs, muck and scrap vaporized into a stench that ripped through the light veil of his dream like the blade of a sharp knife, exposing the horrible reality behind. He muttered something rough to the stranger in return, got up and stumbling over the bags of garbage plodded away.

He didn't look human any more – rapacious animal, angry and indifferent. How long does he live like that? If you could call it a life? What for? Anger. Anger didn't give him peace. It didn't even let him dwell on death.

The man furiously growled and spat. Then he fell to the ground going berserk and began howling, excruciatingly loud and heartbreaking. He grabbed and scattered the garbage around. Gradually the howling turned into pathetic moaning with sobbing, and he spread himself flat on the ground and was deathly still. His heart stopped beating.

His soul set free from the captivity of life, levitated into the air. It jumped joyfully up onto the kid's bed by the window, darted to the grocery store for a loaf of bread, pinched a crispy crust out of it and, chewing it with healthy appetite, swallowed it in delight. It darted on the bike down the dumpy side road, jerked the backpack of a neighbouring girl on her way to school, smiling and confused looked around and ran faster in the direction of the school. So much joy there was in the childhood! So many dreams!

The soul quietly left the school premises and shut its eyes. It didn't want to see the world any more. The world didn't exist for it. Anger took place instead. The man had been punched and kicked, thrown from one corner of life to another, and every time it was harder and harder

to cope. And, when at last love came into his life he was not capable of accepting it. Leery and growling, he drew back as usual and ran away. After that, the soul remembered nothing but anger.

The soul looked down at the lifeless body spread on the ground. It didn't want to go back in there at all, but it couldn't forget that faraway light of love, friendship and understanding, and it lowered itself down. Making a barely audible sound the man got up and looked about.

The golden beams of the rising sun made its way through the dusk of the descending night. The birds sang happily. Birds… Something painfully familiar was heard in their chirping. And that morning… Home! He remembered his home. He wanted to spit out, like he used to, and blow his nose, like he always did, but he could only swallow his spit and wipe his nose with the edge of his shirt. But he still couldn't remember where it was. Where? His memory frantically and furiously chased about in his mind.

His pace was becoming more confident and faster. He was almost running now, not looking about or paying attention to anybody. He was hurrying H O M E !

Nadia Tretikov is originally from the Ukraine and has lived in Canada for the last eighteen years. A writer and poet, she has been publishing poems and short stories in local Toronto media since 2003. More recently, she published a thriller The Running Elephants in 2009, in Russian, and two English publications in 2014 and 2015. Nadia is an accomplished artist and photographer with an 'eye' for the unusual. She creates unique caricatures and images with freehand drawings. Her artwork often accompanies a poem.

REMEMBERING TRIGGER

I had the pleasure of visiting Chennai about 10 years ago with my wife and two children. For my wife Sylvia, it was a long-awaited family reunion as she had not seen her parents and married sister and brother for many years.

We lived with Sylvia's parents for most of our stay in India and spent New Year's in Goa. While in Chennai, I would wake up each morning and read through the morning newspaper. My father-in-law Ignatius and I would do our best to complete the crossword, which we enjoyed over a cup of tea. While browsing through the paper one morning, I came across an article, which seemed to immediately capture my attention and has remained imprinted in my mind. What I read that morning pertains to the Tsunami of 2004 that killed a million people in the affected areas.

I have re-written this story in my own words and it carries a message 'Never ever take your loved ones for granted.' What I plead is for us to remember that life itself can never be taken for granted. As humans we sometimes tend to forget as something else comes along and life goes on and people get back to their everyday mundane things. That is how it should be; to move on, and as we do move on, to keep in mind that what made many stop to think and shed tears, that the tragedy of those involved helped us look at ourselves, and to take nothing and no one for granted.

All those we love, family and friends. Then despite this great pain we would have gained some good to make our lives and the lives of others a little better. So here goes...

Never take loved ones for granted:

Eric Brown was a bachelor, living in the city of Santhome (Chennai) and his only companion was his dog Trigger. The faithful dog never left Eric's side and Eric took care of his pet like a family member. With

Christmas approaching (2004), Eric's married brother Keith who lived in Australia, planned to come down to Chennai along with his wife Marlene and teenaged son Mark for a long awaited and eagerly booked reunion with his brother in India.

The family arrived in mid-December and spent some joy-filled, happy days together, catching up on old times when they were young. Eric was delighted to hear of how their lives were in the 'down under' part of the world. He enjoyed hearing his only nephew tell of how he enjoyed his school and things as such. Eric took them around the city of Santhome and Chennai, two of the most bustling cities in South India. He loved taking them to see the sights and sounds. Especially watching his nephew's face light up when he saw something new and exciting, like the hawkers selling their wares, people bustling about in their daily chores. He got a kick out of seeing a young pretty girl look at him, smile and then turn her face away in shyness. It sort of left him breathless, or so thought Eric with a smile. It was all so different for his young nephew. Eric watched as his nephew seemed to be taking it all in and to Eric it seemed this young boy was sort of in a daze, a happy daze.

Christmas Eve approached. On the 24th, they attended Midnight Mass at the St. Thomas Mount Church and returned home to exchange gifts, share some memories of Christmases long gone and partake in a round or two of 'daru', the common Hindi word used for any or all liquor. The next day was spent visiting with some of Eric's friends and neighbours. This was another wonder for Mark, as they visited friendly people, sampling their traditional cakes and sweets, all homemade. Keith and his wife enjoyed it too. Keith had almost forgotten the taste of these delicious treats made once a year. This was a rare and new experience for Mark and his mother, something that they had never experienced in Australia; warm, traditional Asian hospitality and culture.

Boxing Day arrived! Eric woke them up early at 7 a.m.

"Let's go for a walk on the beach! You are going to love the sunrise," he said.

His family were all game and so was Trigger, as this would have been his normal routine on any given day. Tail wagging, he ran for his leash, returning with the same held in his mouth; tail whipping the sofa, coffee table and anyone else who got too close.

"Here, you take him." Eric handed the leash to his nephew Mark, who was more than delighted and fastened the collar on the now very excited dog. Soon as the collar was on, Trigger dragged the teen towards the front door, choking on the collar.

"Easy, there boy, slow down!" Eric said loudly to Trigger.

Keith and his wife Marlene quickly got changed and they all left for the beach, a short walk of about three blocks. The sun was just peeking out over the horizon; casting an orange glow on St. Thomas' Church which was mostly white marble.

"Oh the church looks so beautiful!" exclaimed Marlene gazing at its majestic glow.

Keith and Eric agreed, while Mark was being dragged off by an eager Trigger, both headed for the nearby beach. Small waves pounded the shore in a never-ending song and dance of the sea. They walked east, towards the rising sun and after about ten minutes of walking and chatting together, Trigger suddenly began tugging on his leash straining to get back to the road that ran along the beach.

"Uncle, I can't hold him any longer. You take him," Mark cried out to Eric handing him the leash.

But before he could take hold, Trigger ran off, dragging the leash with him. He turned around, looking at them, barking frantically, tail wagging.

"Come back now Trigger!" Eric ordered, but the dog kept running up the beach, turning around and barking again. Each time Eric ran after it, the dog ran off again, further up the beach till he almost reached the main road.

"Wait here, I'll go get the mutt," Eric said to his family as he strode off up the beach, wondering what had gotten into the dog to act this way. He had taken about fifty steps up the beach, chasing after the barking dog who seemed bent on getting away from him.

"Get back this minute!!" Eric called out, but Trigger kept running away, then turning around and barking excitedly at him.

Eric was breathless now and stopped to look around and wave at his family. He froze in absolute terror at what he saw: A giant wave about two storeys high, rose out of nowhere and was speeding up the beach towards his brother's family. They did not have a chance to run, but

stood as though spellbound and in a second they were gone as multiple wave after giant wave came in and swept them away along with some other people who were out on the beach that morning.

There was nothing Eric could do. Shock, dismay, a panicky feeling of helplessness took over and he dropped to his knees sobbing. Trigger came up and licked his face.

A million people around that region of the world lost their lives that fateful day. Eric was inconsolable. The bodies of his brother, sister-in-law and nephew were never found.

His dog Trigger died two years later and it was an article dedicated to his dog "Man's Best Friend" that I happened to read that morning in Chennai. Animals do have this sixth sense and this is what Trigger was trying to warn them about; an approaching tsunami.

And so to say again, life is so very unpredictable. You could be here one day and gone the next; so could your family and everything else. We should try and love our dear ones every day with all our heart and tell them each day, with a hug, looking them in the eye, especially our children and say "I love you"; for we know not what tomorrow or for that matter, the next moment may bring.

Wayne Croning is the author of Karachi Backwaters *and several short stories, two of which were published in a magazine called* Anglos in the Wind. *Born and educated in Karachi, Pakistan he immigrated to Canada in the early 1990's and works and lives in Winnipeg with his wife and two children. History, boating, reading and writing are his main hobbies.*

Kiran Sawhney

EYE SEE

eye

cross the high tide
to a rugged land inviting me to be part of its story

a tale of two countries, two solitudes, two peoples
woven in a tapestry with harlequin thread

justice masquerading in the laws of a nation
whose bounty is steeped in an eloquent mirage

lift me to heights and plateaus with a lyrical finesse
lulling me into illusions of grandeur

masks of opportunity step softly, delicately
tantalizing my ambition, vacancy eludes, evaporates

anguish marks the furrow of my brow and the tip of my pen
when the hue of my skin dilutes the weight of the words

entrenched in the codes of corporations and organizations
daring, pricking, igniting the spirit of equality

eye

bask in watershed victories of struggle
buoyed by my kin who resurrect the script of tolerance

with a resolute rigour and deafening defiance,
stenciling the landscape with latex impression

UNSHATTERED

You are the child of immigrants who laboured to survive
in a brave new world where they had learned to deprive

Your face flushed as your body heat rose
and each limb in your fragile frame froze

The kids jeered and mocked you for being Indian
Forcing you to hide in utter oblivion

Standing still no walls to shield from the insidious torment
unable to retort with meaningful comment

Confused and shattered as they boasted and taunted
Sucking out the oxygen, leaving you forever haunted

Not quite capable of comprehending why hate was even a thing
Vile open mouths shooting arrows like a heavy sling

Silenced by the wanting of unconditional acceptance
Making invisible the cruelty of unconventional adolescence

Your mind wandered full of shame and guilt
Façade and mirrors you took pride and built

Hiding from the skin that wrapped you so tight
Peeling you back from your struggle and fight

Swallowed your pride when you sat alone and cried
Terrified nothing would change until you died

Something inside said rise up and show the cracked veneer
Don't let your soiled spirit drown and disappear

You are the child of immigrants who laboured to survive
In a brave new world where they had learned to deprive

Kiran Sawhney is an ESL teacher who has been writing poetry for many years as a quiet passion. She is currently working on her first collection of poems. Her poetry is informed by her experience of growing up brown in the 60s and 70s in Canada.

Milena Marques-Zachariah

WHEN 'KHANDAR COAT' CAME CALLING

This was a time before Whatsapp, Facebook, Instagram, Twitter, Snapchat and email. The days before cell phones became the ubiquitous accessory in everyone's pocket. The era when most people didn't have a telephone in homes to chat and connect. When people sent telegrams to inform their relatives and friends of deaths, births and weddings.

Indeed, it was the best of times and the worst of times in Goa, India.

Now, let's set the clock back 25 years to revisit a sleepy village, sprawled between two hills, with swaying palm fronds, verdant paddy fields and sturdy mango and jackfruit trees. The church, chapels and temples stood like sentinels, guarding the faith and fervour of two religions that were moral markers for the village.

Life in this village was no different than any other in a once indolent Goa. The afternoon siesta was invariably followed by a '*passoi*' or leisurely evening stroll, almost always disrupted by the barking of stray dogs, angry at being disturbed from their slumber on the street. Poor folks worked hard in paddy fields six days a week, and on the seventh day, dozed off in church while the vicar and his assistant tried hard to save their souls. Here, people's minds were also steeped in superstition. You never clipped your nails at night; beware of the female cobra, she always sought you out for revenge if you killed her mate; the crow has cawed, so the mailman will come calling.

We kids never kept a watch for the postman. Instead, we kept a sharp lookout for our 'personal postman.' He brought the best kind of news - fresh off the press as it were: invitations from our relatives to the 'feasts' of patron saints that were celebrated in each village. Invitations to spend holidays by the seaside. Letters informing us about an impending wedding. Yes, he almost always carried news that excited us kids. We kids never knew the man's name. We knew him by sight. Rake thin, he always wore a full sleeved shirt tucked into trousers that stopped many inches above the ground, silver hair combed back neatly, clean shaven

and barefoot. His signature style was a jacket casually thrown over his shoulder. This jacket or coat was always flung over his shoulder, earning him the moniker 'Khandar coat.' Literally, jacket over the shoulder. Sometimes, he wore a hat. We kids spied him long before the adults did. We then sped home to see what news he had brought. He spoke fluent Portuguese and English, and my parents always treated him with deference. His good looks were as worn out as his threadbare coat. His manners, however, were impeccable. He always bowed to my mother, while he gave her snippets of information about this or that relative. He delivered the message in impeccable Portuguese and then took the accepting or declining message back, to be delivered the very next day. But not before he took two shots of the local brew, *feni*. My father never failed to explain to us that he needed those to fortify himself for the long journey ahead. And, after all, he was our family messenger who walked for miles over hills and through fields, bringing us 'convite' or invitations to happy occasions, that inevitably broke the monotony of our village life.

It must be remembered that 'Khandar Coat' was no ordinary messenger. He was educated, reputed to have returned from a stint in Africa where he was some sort of *'empregado'* or clerk. Post-liberated Goa had no jobs to offer him, and he had many mouths to feed. This was how he did it. So we were never allowed to make fun of 'Khandar Coat.' He was, according to my father a *'pobre figalgo'* a poor gentleman, fallen on hard times. So we were instructed to be polite to him and never resort to any kind of teasing, not even furtively. But the village goons didn't spare him. 'Khandar Coat, Khandar Coat' they shouted after him. He occasionally grew angry and cursed them under his breath. Most often, he held himself erect and walked briskly away from their merciless taunts. He only carried messages for the landed gentry and for those who treated him as equal. He was not going to lower himself to these urchins' level.

He had a jacket, didn't he? It separated him from the hoi polloi and even ensured him a drink, seated in the hall or drawing room of the people who knew who he was. He was no ordinary mail man. He carried messages and delivered them with panache. He had a hat, which he tipped, before taking his leave.

The memory is vivid. 'Khandar Coat' walking away with his cream-coloured jacket flung carelessly over his shoulder. His feet covered with red laterite dust, his face flush from *feni*. We knew he'd be back soon, with another message, another 'convite,' another story.

Funnily, the crows never gave us warning of his arrival. Even they knew 'Khandar Coat' was no ordinary mailman.

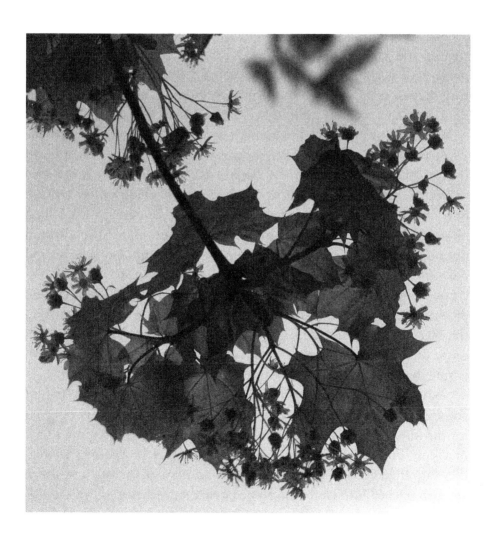

CHRISTMAS TAKES THE CAKE

In Goa, it takes a village to prepare sweets at Christmastime! Judging by the amount of effort that goes into making '*kuswar*' or the traditional Christmas sweet collection, frankly, a village is what is required.

'*Kuswar*' immediately conjures images of the most delicious and delicate sweets that generally take ages to prepare. Top on the list is the delicious and crispy '*neuris*' – Goa's version of perogies. Then there's everyone's favourite: '*kulkuls* – tiny, irresistible, melt-in-the mouth, sweetened and fried dough. Let's not forget the jiggly *dodol*, made from roasted rice flour and jaggery and coconut milk; the gram flour and coconut sweet *doce*; the lovely *pinaag*, little croquettes of rice flour, jaggery and ground coconut; the '*bathica*' Goa's unique sponge cake made with coconut; milk toffees; colourful marzipans in a variety of fruit shapes; and the queen of them all, *bebinca* – a heavenly mixture of flour, eggs and coconut milk, baked patiently, layer by layer.

When the misty, cool December air suddenly gets filled with the sweet smell of fried dough, you know that the village has woken up to the task of preparing '*kuswar.*' A week to 10 days before Christmas, the collective effort to prepare Christmas sweets begins. Housewives are seen hurrying, post lunch, to pre-determined homes, clutching their rolling pins and boards. They arrive to mats and clean white sheets spread out on the floor. Each person is given enough dough and flour to roll out *neuris*. And while one rolls out the dough, one places the filling—coconut and jaggery or sweetened lentils, pressing them down, cutting off the excess with little cutters. Someone else creates little patterns on the edge of the *neuris* and finally, they are ready to sizzle in hot oil, until crisp. But first, a cross, made of dough, precedes the frying. This is to ensure that all goes smoothly with the frying.

While the *neuris* are frying, another group, usually comprising of younger girls and boys are busy make *kul kuls*. This task is reserved for the kids, because it's fun to make them and may not require much precision. Pre-ready dough balls are rolled on a fork or a comb and then these are fried crisp to perfection. Piles and piles of *kul kuls* and *neuris* are then packed into large tins, to be opened on Christmas eve.

And while all this is going on at breakneck speed, gossip circulates at

the same pace. That's when you know who's run away with whom, who's got engaged, and who's pregnant. Sometimes the ladies break into song and invariably guffaw at a raucous joke. Nothing is off limits. Except when a kid tries to steal some dough or filling. Furtive hands are swatted away with a stern warning, "Only a few days for Christmas, then you can eat until your belly hurts."

And invariably, the belly does hurt, with all the fried sweets that have gone into it. The sugar meter, too, is at an all time high. Today, dietitians would balk at the overload of sugar and oil. However, all caution is thrown to the winds when traditions have to be preserved, and passed on. Traditions cannot be allowed to die.

Then Christmas day arrives. Trays, laden with sweets, placed on a white, frilly doily, are exchanged between neighbours. Of course, there are little or no surprises. Everybody knows what everybody has made because everybody in the village has contributed towards making Christmas a little sweeter.

Milena Marques-Zachariah is from Goa, India. She is proud of her Goan heritage and promotes her culture through her writing and the medium of radio. In 2012, Milena founded Radio Mango – the only radio program in the Konkani language in the northern and western hemispheres. She produces and hosts this program every Saturday for two hours. Her vision is to keep the Konkani culture and language alive for the Konkani speaking diaspora in Canada. She also writes a blog Ideas out of My Mind *giving insights into an immigrant's life. Milena lives in Mississauga and is very active in the Toronto Goan and South Asian communities.*

P.I. Kapllani

THE PARTICLES*

Based on the life of my father I. Kapllani, who was found dead in a street in Elbasan, Albania, on February 1977 at the age of 43 years.

"Siemens AG, Convulsator!" Isa Vishanji softly read the brand of the electroshock machine. The yellow box had a handle on top, from which two electrodes extended like two deadly tentacles of an octopus. He peered through the little glass of the wattmeter and saw that the needle had stopped at zero. A green button below the glass looked to him like the sole eye of an evil monster. He had to take note of the details and repeat the info back to himself. He believed that repeating aloud to himself what he saw, would strengthen his memory. It was the way to knowledge—learning by rote. He would fix in his mind even unnecessary info.

It was the third time that he had been taken to the electroshock room, even though the electroconvulsive therapy didn't seem to have any effect on him. The director of the hospital, Dr Dinçi, had himself conducted the therapy on him. His name and grave bearing heightened Isa's fear. Two burly nurses held him by both arms and dragged him across the floor toward the portable bed, which was covered with a white sheet. Isa glanced down at himself. He wore white pajamas with a brown rectangular pattern and torn slippers on his feet.

He clenched his teeth tight to hold back the cry of fear that threatened to escape his dry throat. The more panic he expressed, the longer the electric shock treatment would last.

In the few seconds of relative normalcy, his life replayed backward in his mind, like a black-and-white movie. He saw the silhouette of a gray airplane travelling from Moscow. He was on a flight home after receiving a Communication Engineer's qualification. The airplane sank into cloud, but the sweet, bright face of Svjetllana was still before him, as he left Russia forever. Many Albanian students took their Russian girlfriends with them, but Svjetllana didn't want to go to Albania.

"Stay here with me," she begged him, but Isa insisted that they must live together in his homeland Albania. Since their minds were in different places, they had to break up. Svjetllana had cried all night long. She kept begging him to abandon everything and spend the rest of his life with her, but he couldn't bring himself to do that.

Since the day they broke up, he had felt lost. His mind couldn't come to terms with losing her. He had a nervous breakdown, which led him into deep depression. He had gone into his room and shut the door behind him, locking himself inside. He relived the memory of those unforgettable moments with her, when he held her in his arms. The brilliant student Isa Vishanji had turned into a zombie who walked in his sleep through the streets of his hometown Elbasan. The brightness of Svjetllana's eyes woke him up even from the deepest dream, but she wasn't there anymore. She was thousands of kilometers away.

Isa couldn't do anything else. He didn't want to eat and he isolated himself from the rest of the world. A confusing tangle of pain and sorrow for his lost love settled like a heavy burden on his heart. The promising youth who had once won a gold medal for mathematics had transformed into the 'living dead.' He didn't speak to anyone. His father was so worried about him that he took his son to the Psychiatric Hospital of Elbasan, where Isa stayed time after time. The doctors prescribed many different kinds of antidepressants like Venlafaxine, Bupropion or Imipramine, but none of them worked.

His family couldn't agree with his desperate and tragic state, especially his older sister Shpresa, who introduced him to one of her girlfriends from school.

He married twenty-year-old Brunilda, with whom he had two kids. The image of Svjetllana had faded, as the nervous breakdown took its toll. The more he tried to get rid of thoughts of her, the worse his mental state had become. In a moment of high anxiety, Brunilda caught him with a photo of Svjetllana in his hands and finally asked him for a divorce. He saw his kids rarely, even though he lived in the same city as Brunilda, who was now married to someone else.

"Close your eyes and don't move!" Doctor Dinçi ordered him, as two nurses tied his legs and arms to both sides of the iron bed. Isa knew very

well what would happen next. Doctor Dinçi would turn the knob on the electric shock machine. The electric impulses would surge through both sides of his head simultaneously. Isa had seen many patients in ward 17 during the last six months that he had been treated in this hospital. The shock therapy wasn't the best. It had side effects such as partial loss of memory.

After going through that unbearable treatment, he was supposed to get back on his feet, yet his mind struggled to bring back to his destroyed memory all the people he had loved. How could he forget the little and innocent faces of his son and daughter, Ajri and Lulja? Ajri was 10 and Lulja 7 years old. He had promised Ajri that he was going to buy him a soccer ball and a box of colourful pencils for Lulja after he got out of the hospital. She was so eager to draw and colour and Isa wanted to support his daughter's passion.

"Ajri and Lulja! Ajri is my son: 'ajer' means 'air,' the air I breathe. Lulja is my daughter—the flower of the spring, who likes to draw waves on the seashore, homes, trees and animals. Dear son! I don't know if you will be able to understand one day how much I have suffered. Tonight I am being treated with electro-convulsion. I am trying to forget the pain. I wish you with all my heart all the best in your life. I hope you have only joys and become educated and smart. I wish you grow up fast and become a real man. I don't know why they don't let me see you. I stare at the walls and I don't feel like doing anything. I miss you so much, my little king. The only person who understands me is Albin, the doctor on the night shift. He gave me a notebook and a pencil for good behaviour. I write down some particles of my memories and this way I keep my memory alive. I have hidden the notebook under the pillow. I'll write everything down, when I get back from the therapy."

Isa felt the electric current rattle his tired brain. Images crashed and folded into each other. He clung to the rubberized bars of the stretcher, as his mind spun like a turbulent whirlpool. Fragments of memory melded together. Svjetllana shook hands with his son Ajri and kissed Lulja on her rosy cheek. Brunilda laughed at him with sarcasm from the distance, as she appeared on the sidewalk beside a young and handsome man. The thunderbolt sliced the dark sky of the night in pieces, as the approaching thunder resounded in his ears. He saw his tired body slide downwards

and disappear without a trace into a black hole in space. Where had he been? His brain felt it would explode from the high pressure applied from all directions. If this treatment destroys his memory how could he live without the memories which kept him alive?

"I'll memorize all the details in the notebook," he promised himself and clenched his teeth with pain. "I should not forget them. These notes will keep me alive. I'll write them down one by one!"

<div align="center">***</div>

Before I went to the electroshock room. I was given some disgusting soup, which stuck in my throat. For breakfast I had just plain bread, tea and a piece of yellow cheese. The tea was chlorinated and the yellow cheese stank, which I hardly ate. I shouldn't complain, since I had seen worse. I have seen patients eating from the garbage bin. There is no rule of law behind these walls of this hospital. There is no respect for humans! When they position us in line for the morning exercise they call us not by names, but by numbers. My name is Number 12 from now on, but all of us are called by one collective name: "The Animals!" Last night three "patients" entered my room and beat the hell out of me. They hit me with the legs of a broken table and kicked me nonstop. I fought back to defend myself as much as I could. Once I thought to jump from the fifth floor, but then I remembered the windows up there are also fitted with iron bars.

How is it that there are so many bad people around, people with no soul? I can hardly breathe and my back hurts. Ufff! I think they induced me into having more seizures. I want to tell the doctors: Please, take these electrodes off my head, since you are not going to cure me. I am afraid that I am going to die without being able to see you for the last time, son!

They gave me an injection in my arm and put me to sleep. I don't know how long I slept. When I woke up, I noticed that I was in handcuffs. An intelligence officer stood in front of me. He introduced himself as 'Fatmir.' He had a short mustache and a huge pair of reading glasses. His military uniform hugged his body, and he lashed his fine boots with a whip. He asked me how did I know Svjetllana Konstandinova. "I didn't tell you before that Svjetllana was my Russian girlfriend" I said to myself. Perhaps I had mentioned her name in delirium and now they are trying to destroy me. This officer with the name 'Fatmir' accused me of being a secret agent of the KGB! - The Russian intelligence agency. How can I be an agent, when it

was me who won a gold medal and chose to come back to my country above all? Definitely it has been a misunderstanding and I believe that they will get me out of this hospital-jail. Hope dies last, not the soul. Soon I will join you, son!

<div align="center">***</div>

Isa Vishanji opened his eyes and threw a tired look around the room. The shock therapy had ended and the doctors had taken him back to his room, where five more patients were accommodated. Six patients in one tiny room. His body was numb and his bones felt broken, but the shock therapy didn't have the results that they were expecting. The shocks couldn't destroy his memories. Svjetllana, Shpresa, Brunilda, Ajri, Lulja, Albini…all the people out there with whom he managed to have some kind of relationship—their names were written down on the yellow pages of his notebook. He caressed it and hid it under the pillow and laughed triumphantly. He had particles of memories that they would not destroy.

P.I. Kapllani is a multi-published author, who writes in English and his native Albanian language. His English books are: novel The Last Will, *based on the Çamëria genocide, 2013;* Beyond the Edge, *short stories in 2010; play* Queen Teuta of Illyria *in English in 2008 and in Albanian in 2014; and* The Wild Boars, *2016. His writing appears in numerous anthologies. His novella* The Hunter *was shortlisted by Quattro Books for The Ken Klonsky novella contest in 2015. He has published four books in Albanian. He graduated as an Anti-Aircraft Gun Artillery Officer in 1990 from the University of Scanderbeg, and has a teaching degree in Literature and Albanian Language from Tirana University.*

Joanna Gale

THE STONE ALTAR (SEPTEMBER 18, 1918)
(for my Grandfather Brinley Newman, died at age 22 in WW1)

Lions roar from the stone's altar

> *hundreds and thousands of names you see*
> *our officers didn't always agree*
>
> *along the way many fell ill and died*
> *we were half our normal strength*
> *the mountains high*
> *we built our own roads and railways*
> *where malarial rivers infested us*
> * 'The Gardeners of Salonika'*
> *called to do battle on the ridge of the hill*
> *when our camouflage of fog rolled in*
> *and our unit stormed the slopes*
> *of the Grand Couronne until*
> *its veil lifted left us*
> *exposed for the massacre...that day*
> *the war was over*

The monument's story is the only voice we hear

> Oh I hope the end was swift
> for the father our father never knew
> ...medals?... yes we have a few
> (brave bones gone somewhere...we'll never know)

The obelisk reaches the sky's blue

> marble holds his honour carved

in a country not his own
we the family hold him
buried in the culture of our blood
mourning that which is within us
lost across
the sea of loss

(Doiran, Greece)
Gail J. Dickie (nee Newman)

TRENTON TO TORONTO

Who are these soldiers who stand on guard
at home and abroad on distant shores?

Banners of Canada wave and wait
Overpass overpass over
The envoy's procession crossing
The Memorial Route horns blasting
Grandstand maple-leaf salutes

Flags lowered — tributes raised
Mark each fallen soldier's passage
Where they've been — what they've done
What they have become — brave
Iconic Heroes of the Highway
History rolls beyond Port Hope

'Lest we forget'

RACHAEL

(my granddaughter)

The gold of your wings glow
like buttercups we used to hold under our chins
to reflect upon our skin (I can't remember why).

Did you know:
fireflies cannibalize themselves
rattlesnakes move fast — very fast
snapping turtles float like logs on ponds, difficult to identify
and whiskey jacks nosedive from trees — vicious
Always something fluttering about,
It's wise to keep a flyswatter close by.

Yet, bluebirds wait to perch upon our shoulders;
and you are young with miles of green green fields
whispering messages especially for you
my beautiful bird of the wind.

Joanna Gale is an award-winning poet, widely published in chapbooks and anthologies with two poetry collections to date. This past year she is enjoying her attempts at Chinese Brush Painting as well as the art of watercolour. She lives in Markham with her husband.

Josie Di Sciascio-Andrews

IF SHE WAS AN ANGEL

It's strange about synchronicities, how they can throw us for a loop around the bends of time, reconstituting memories, people and events we had forgotten, as if the years had not elapsed: serendipity tapping us on the shoulder, through the fabric of space-time, brimming with prophetic meanings. Such was the unexplainable coincidence, that like only two other pivotal times in my life, brought me to the brink of mystery, to question everything I had ever thought I knew about reality, putting my belief on the solely tangible on the line.

It was, in fact, quite unusual for me, especially on a Friday afternoon, to make my way from my classroom to the teacher lounge, situated in the furthest wing of the school. With everyone already eagerly gone home for the week-end, it was stranger still that I did go in there, on that particular day, lights dimmed and all, compelled by the sudden urge to check my hair in the length view mirror. Stacked on the floor, were several complimentary bundles of *The Hamilton Spectator,* a paper I usually never buy, but I was equally, casually compelled to pick up a copy for later perusal.

If it's cliché to say that truth is often stranger than fiction, such truism materialized for me on that particular day in ways I couldn't have anticipated, with spirit cracking through my world's material dimension, for no other reason than to connect and to let me know that we are a part of something greater. It was as if God, the angels, the universe or whatever matrix inhabits the psychic realm, had decided to come through to me specifically, in order to remind me, with the mind-blowing thought that, indeed I am not, and have never been alone. The whole thing that transpired could have very well been a total coincidence, but the sequence of small details, which successively led from one thing to the next, although inconsequential in themselves, added up to reveal a story nothing short of extraordinary.

I drove home with the sole thought of making dinner. I remember placing the newspaper on the kitchen table, while chopping vegetables

and breading meat. Once I had everything set and the skillet of veal and peppers was simmering, I poured myself a glass of wine and sat down to flip through the pages of the *Spectator*. Randomly it sliced open to the obituaries.

As my eyes honed in on the first death notice, a shiver ran through me. It was a name I knew very well, a name I hadn't seen or thought about in decades. Lina Borsoi, the French teacher who in 1968 had helped me to survive my transition from Italy to Canada. The impact of the news that she had passed away filled me with sadness. Moreover, the awareness that this fact had somehow made itself known to me, in such a coincidental manner, yet so clearly a message for me to heed, struck with the full weight of its significance. It was a meaning I had not formulated or paid much attention to for a lifetime. On the occasion of Lina's death, it had arrived to announce itself to me, shaking me out of my existential slumber. It had come to speak to me of destiny, of soul, of purpose. This was a crucial piece of information, meant for my eyes only.

I had met Madame Borsoi in 1968, the year my family emigrated from Italy to Canada. She had the gentle, caring ways of those rare teachers who change the course of young students' lives. She was firm, yet kind with a demeanour that set her apart, a compassion of the heart that made her quite unique, and to which I was immediately drawn. I remember the first day she walked into Mr. Lamoine's grade eight classroom, with her large storyboards of *Ici on Parle Francais*, with, the then popular, cartoon illustrations of *La Famille Benoit*. Who could ever forget the Charlie Brown-type characters and their infamous dog *Pitou*?

Madame Borsoi didn't know it, but with her repertoire of visuals and story boards, together with her cool sense of style, she made viable for me the possibility of a life in Canada, a thing I had been seriously doubting since I had arrived. Many were the times when I had cried on my way to school, with frozen hands and toes, in inappropriate winter clothing. Language, culture and temperature shock, as well as coping with my parents' own struggles with language, work and their own grief of loss, often made me wish to return home to familiarity, wistful of kissing the warm soil once I got there.

At first I didn't know Madame Borsoi was Italian like me. Fair and

gentle, a native of Veneto, she had the grace of a blue fairy godmother. She exuded kindness and knowledge, unlike some of the other teachers, who slapped rulers on desks and dished out detentions for every misdemeanour like they were traffic tickets. Mr. Lamoine was the only other exception to this child-unfriendly school-scape. I realize now that he and Lina must have been in cahoots. You could see it in the way they interacted. They knew where each other was coming from, and it was this intuitive, emotional intelligence with kids that made them stand out from the rest. If Lina was a cool, trendy dresser, Lenny Lamoine looked like a newscaster from the 60's CBS. White shirts, khaki suits and fancy ties earned him fame with his students, for his professional style, the kind of respect given to television anchormen. He fit in perfectly with my imagination of those tumultuous times: of my family's immigration to a new world; of my adolescent debut into the foreign; and of that very year's mythic landing on the moon. Having just returned from Kenya, with his stories of lions and African tribes, Mr. Lamoine appealed to our young imaginations, with his exotic tales of the then famous TV series *Born Free.* I remember the day he brought spears and headdresses of the tribes he taught in Kenya. He had a way of bringing learning and the world to life.

Probably because of his experiences in Africa, as well as his compassionate nature, Mr. Lamoine understood me and the other immigrant kids. He didn't exhibit any of the preconceived notions that other teachers seemed to have about us: like for example, that we were slow or culturally backward because we didn't speak English or wear the 'in' clothes. Lina and Lenny took care of us. They rounded us up and gave us room to grow. Though we were unaware of it then, they probably schemed strategies that would ensure our success in our new Canadian world. To such aim, we were given roles of responsibility in the student council; parts in the choir; jobs as decorators of the school foyer at Christmas; and leadership positions teaching English to the newest immigrant arrivals. It was genius on their part to instil in us such sense of capability, of self-worth and belonging, despite our many hardships and setbacks. They planted seeds that would grow and serve us well to continue striving in our futures.

Madame Borsoi was a married mother of two boys, much like I am

now. She was petite, intelligent, fashionable and kind. It followed, as a matter of course, that French soon became my favourite subject. I looked forward to her arrival in the classroom, to break up the monotony of the rest of the school day. It helped that French was so easy for me to understand, due to the fact that it's so similar to Italian. French became the middle ground for me, the common denominator language between my old world and the new. It became my comfort zone in a context of the otherwise unfamiliar and foreign. There were other students who had just landed from other countries just like me. Some were from Greece, some from Scotland, England and Yugoslavia. We all stood out, had accents and therefore clung together, despite our different languages and cultures. I remember Lynn, the Scottish girl with the heavy Glasgow accent, who soon became my best friend. Although from different countries, we stuck together as foreigners in a new world that hesitated to welcome us in.

My first contact with the Anglo world was at Lynn's house. It was where I ate my first dinner of roast beef, followed by cherry Jell-O, cut in small wiggly cubes and topped with Cool Whip. Conversely, she would come to my house and for the first time, ate homemade pizza, pasta, and yes, wine. We teasingly argued about rinsing or not rinsing the dishes. Italians rinse them ten times. She dried them with suds still on them. Little nuances of culture everyone takes for granted. Like saying "I washed my hairs," perfectly acceptable translated from Italian, but totally ridiculous in English. "I washed my hair," she would insist. Hair is singular, and it would dawn on me that the image was funny: one hair mass on the head instead of thousands of hair follicles. Our friendship grew of these small things. Like typical girls in grade eight, we talked about clothes, boys, music and TV shows.

Those were the days before English as a Second Language classes. Madame Borsoi must have read it in our faces that we were struggling. Either that or Mr. Lamoine must have told her, because it soon came to pass that she would drive us to her house on certain evenings, with our parents' grateful permission, to teach us English at her dining room table. She took us into her home, on her own free time, out of the goodness of heart, because she felt sorry for us, because she cared for our success.

It was Lina Borsoi who comforted us when other kids taunted us with ethnic slurs. Lina who followed me in the girls' bathroom one day, when I was crying over one such cruel comment. It was Lina again who cleaned me up of a bleeding nose after I was hit in the face by a baseball during a game. She called my parents, drove me to the emergency department of the local hospital and stayed with me until my father arrived.

Madame Borsoi, my guardian angel! How ungrateful I must have seemed to you when in the following years, taken as I was with the task of fitting in and succeeding, I forgot you. Believing I had left you behind in my faded memories of Oakwood Public School, certain you belonged to a sad chapter of a past I so wanted to overcome and forget. You were there in one of the most traumatic moments of my life. You were a light in my painful transition from growing up with one cultural identity to shifting into another. In the 60's there was no concept of multiculturalism. You were either Canadian or you weren't. If you were not, then you were an immigrant, a foreigner.

In small town Canada, before globalization, children arriving in the 60's either culturally swam or died. Having an accent was not a luxury. You had to learn quickly to speak proper English, to integrate and fit in. Madame Borsoi helped me to swim through the cultural quagmire of those times. If I lost sight of her, it wasn't because I didn't care, but because life pushed me forward, away from the pain of that time, into new endeavours and new growth. High school with all its academic and social pressures, as well as a part-time job to save up for college, swallowed up my thoughts and time. I lost my father in my first year of university. Worries and responsibilities to make it in life became pivotal, especially as I tried to help out my mother and my younger sister, all the while going to school and working.

It wasn't until I was in my twenties that I saw Lina again at a cultural event. She was proud of my academic success. I remember telling her then, how grateful I was for what she had done for me and the others back in the late 60's. With her usual benevolence, she had shrugged it off as nothing that anyone else wouldn't have done. She switched the subject to the music playing in the background and we talked about her favourite Italian musician, Lucio Dalla, who in her opinion, wrote the

most poetic lyrics of all other songwriters. "*Se io fossi un angelo*/If I were an angel" the tune playing, she said, was her favourite song: an omen of what she was to become for me; what she already was.

There are kairos moments in our lives, but we don't recognize them as such while they're happening. I did not know it then, but for me, 1968, that first year in Canada, was one such time. Impressions were made; futures etched; unconscious decisions formulated; personas tried on for size and identities forged. Becoming Canadian became possible for me, and not in the way of my parents, but in the style of the new society welcoming me in, such as was embodied by Madame Borsoi. She was the role model I could aspire to, the epitome of the possible.

Perhaps the biggest lesson she taught me was that the smallest acts of kindness are often the greatest catalysts of hope in a child's life. With her metaphorical fairy wand, she grounded me to a new landscape and context, knighting me a citizen. Although I never made the conscious decision to emulate her, it is sort of interesting that today, I am a French teacher. I do love Lucio Dalla's music too, but that is quite coincidental. More than emulation, it was perhaps our kindred natures that made me admire Lina, both as a teacher and as a person. Perhaps there was something of herself that she saw in me too, of the way she was when she first arrived to Canada as a child, for which she felt compassion. She knew what my foreign friends and I were going through. In the 60's being Italian in Oakville, a very rich suburb of Toronto, was like being a Biafran in Nunavut. I missed Italy terribly and not in a patriotic sense. It was more immediate than that. It was physical. It was cold for half of the year, it seemed, and there were bullies taunting us for looking different and not speaking the language.

In retrospect, had it not been for Madame Borsoi, I don't know if my life would have taken a different turn. The fact is she was there to soothe my transition into my new world, fostering in me a positive view of the future and sending me off like a sail on the ocean of my life. It took the unlikely coincidence of reading her obituary, one Friday afternoon, in a newspaper I almost didn't pick up, to catapult me back in time, showing me the importance of this one key person in my life.

It is for Lina Borsoi that I write this story, but also for all the other teachers who have made and continue to make a difference in the lives

they touch. It is with gratitude and love that I write these words, to an angel who would otherwise remain nameless. And it is with a heavy heart that I salute her in the language of the country she taught me to love: "*Merci beaucoup et, au revoir Madame!*"

Josie Di Sciascio-Andrews *has written five collections of poetry:* The Whispers of Stones, Sea Glass, The Red Accordion, Letters from the Singularity *and* A Jar of Fireflies. *Nature and one's place in it, as well as memory and social justice are her muse. Her poems 'The Red Accordion' and 'Emerald City' were shortlisted for* Descant's *Winston Collins Best Canadian Poem Prize and* The Malahat Review's *Open Seasons Award respectively. In 2015, her poem 'Ghost' received first prize in Toronto's Big Pond Rumours Journal Contest. Josie is the author of two non-fiction books:* How The Italians Created Canada *and* In the Name of Hockey. *She lives, teaches and writes in Oakville, Ontario, Canada.*

Norma Nicholson

RAY OF HOPE

Dedicated to my brother Ray

Ten years old and my hunger burned
For food and love denied.
A small glass of watery powder milk
And two ounces of cheese
Nourishment received not at home
But in school.

Food withheld as punishment
Punishment for what? My child's heart cried out.

Hunger for food, hunger for love
A constant yearning in a bleak childhood

Spirit dies a slow death
When starved of food and love
But for me, thank God, it was not so
For indomitable Spirit keened towards
Any ray of light
That broke through the darkness
Every ray of hope
That shone on the hopeless

Spirit saw and thrived and remembered

Remembered the dark day in the life
Of a ten-year-old with a gnawing hunger
Running with a flask of coffee for the teacher
Running and running, so as not to be late
Falling. Smashed flask, spilled coffee

Running back home
A child's heart pleading to the Universe
To be given another flask, another chance
But the darkness of evil in a guardian's soul
Knew no mercy, knew no compassion
Acted with inhumanity
Tied my child's slight body to a tree
So tight I could not move

Left me to stand all day
Without food or water
Darkness and despair settling on a young soul

But then
A ray of light from a torch
Split the darkness
A small voice whispered hope
Small hands cut the ropes with a knife
A little brother
Led me to shelter
And shared half his supper

That act of kindness kindled hope
That has shone in memory through trying times
That act built purpose, solidified resolve
To be the ray of hope
Shining on others
In their hours of darkness.

Norma Nicholson is a published author, speaker, educator, youth and adult mental health expert. Her book Young Lives on the Line: You can make a difference, *was born out of her practice as a healthcare manager in the largest secure youth custody facility in Ontario and her community engagement with youth and families. She is a Registered Nurse, with a BA in Sociology and Psychology from the University of Toronto, and an MA in Adult Education from Central Michigan University, USA. She has served on the boards of several community organizations and is currently the Vice Chair of the Regional Municipality of Peel Police Services Board and a member of the Ontario Association of Police Services Board.*

Kumkum Ramchandani

THREE WORLDS

In the old quarter
Dog poop lines the street
In neat colourful rows
A big gob of phlegm lands at my feet
I see the round horrified eyes
Of my tour mate
She does not like to step out
In her Ferragamo shoes
She protects her face
The villagers stare at us
Like we're from outer space
Ragged children touch our pristine clothes
Smells of spicy cooking and rotting vegetables
Permeate the air
Mixed with the stench of bodily functions
A woman is washing clothes outside her home
She stops and pushes back her hair with soapy hands
A village temple is redolent with incense
Sights, smells, noise
People people everywhere
Mayhem on the streets
As cattle, scooters and bullock carts
Jostle in a mad dance of co-existence
In the weaver's home
Big-eyed children hide and giggle
The women carry on embroidering
Nimble worn fingers
Eyes modestly downcast
But fully aware of our clicking cameras
Click click click
We click their neatly arranged pots and pans

144 / THE LITERARY CONNECTION VOLUME III

Their colourful bedspreads and decorated tin trunks
Their silver jewellery and pierced noses
Their dignified old people
We invade their privacy
We would never allow this in our own homes
We hold hankies to our delicate noses
To keep out the odour of heated, unwashed bodies
People people everywhere
Living in closeness tolerance
We could never live like this

Some weeks later, in a bar
I watch this lady
Gleaming coiffed hair
Backless blouse and chiffon sari
Cigarette holder and gin and tonic
She beckons the waiter with an arched eyebrow
He listens attentively to her demands
Imperious in her wealth and social standing
High-born daughter of landowners
Kohl lines her eyes
Her lipsticked mouth
Is used to uttering inanities
She orders her third gin
She tosses her mane and flirts with her eyes
Then later she summons her liveried chauffeur
Slips into her gleaming white Mercedes
And glides gracefully away to her next appointment
A party at a minister's house
Or maybe a wedding at a five-star hotel
Or a glittering baby shower
Or a private music session

I am now back in Canada
I am alone at my window
As I watch the snow slither down
Which world do I live in?
Where do I belong?
Where would I like to belong?

Painting by Kumkum Ramchandani

Painting by Kumkum Ramchandani

THE MAHARAJAH

He struts the crumbling ruins
Of his sprawling palace-hotel
Hastily patched up to lend it some order
Rooms let out to bring in some income
His smile is fixed in place
Cannot tell whether it is real
He has fallen on hard times
But his pride seems intact
His walk is still royal
His bearing erect and proud
His tanned face glows with good health
His flourishing mustache
Like a beacon of hope

He is now just an ordinary man
But seventeen women tourists
Hang on to his every word
Drawn by the aura of erstwhile splendour
Cameras clicking to capture his unwavering smile
When they go back they will tell their loved ones
"We met a maharajah and he was so cool"
They don't know the desperation in his heart
An unknown rajah of a remote village
The humble people still fall at his feet
As he takes the fawning women on a tour
"I should do this more often,"
he says in a moment of rare candour.
"The people love it when they see me!"
As we walk the cobbled roads
Avoiding heaps of garbage and human waste
The rajah points out various landmarks
Small terracotta horses which are placed in the local temple
A symbol of wishes to come true
A harmless ruse to attract tourists

To drop dollars into his empty coffers
And of course there is a resident ghost
A dancing girl whose heart was broken
We are supposed to hear her anklets clanging
As she roams the dark corridors each night
Wailing in her everlasting sorrow

"How can you keep up that wonderful smile?"
I ask in my usual clumsy way
For the first time I see it falter
For one second his eyes cloud over
But back again it is, as dazzling as ever
But at least I know now that the rajah is human

Kumkum Ramchandani is a poet, artist, author and yoga teacher. She left her native country India almost forty years ago and since then has lived in Africa, the Middle East and Canada. In 2013, she and sixteen women made a memorable trip to the state of Gujarat in India. This was the inspiration for the two poems featured here. Currently she lives in Dubai. She is the author of Bailey's Blogs, a humorous book, and her poems and art have been featured in several publications. A proud Canadian, she feels that this country is one of the best places in the world to live in.

Lillian Khan

MY HEART LIES IN MUMBAI

My heart lies in Mumbai,
in little *gallis*,
eating *usal*,
sipping *garma garm* Chai...
Gobbling *wada pav* and *kachori*,
calling elders of no relation:
Uncle and Aunty!
The familiar sights and sounds of home,
the market lingo,
bargaining with vegetable and fish vendors at the door...
I miss the familiar streets...
urchins, astrologers,
stray dogs and cats of different breeds.
Sitting in rickshaws,
wind blowing through my hair,
eating in roadside *dhabas*,
braving everyone's stares.
The warmth and love of neighbours and friends,
the endless adventures,
that we thought,
would never end.
My heart lies in Mumbai,
the city that never sleeps,
the sparkle in my eye!

WE WILL ALWAYS REMEMBER

In honour of Remembrance Day

Let us remember,
with love oh so tender,
the brave hearts that did,
their lives surrender...

The mothers who sobbed,
the lovers who cried,
the widows, the children, the family deprived...
They all did pay,
the ultimate price...
when their dear ones in battle,
went missing or died.

We owe them so much,
we can never repay,
those who lost their lives,
for freedom to stay...

We can now all live in peace and harmony,
for the sacrifices that were their destiny...

We will always remember...

THE SHIRT

His shirt lay crumpled on a chair forlorn,
It's owner now a pile of ashes in an urn…
She picked up the shirt
trying to recapture his scent,
was this what life comes to,
in the end…
She tried to trace the muscles of his chest from memory
the shirt held bound in its weave,
yesteryears of birthdays and anniversaries...
How could the shirt
that had once enveloped the man she loved,
so full of fond memories…
Now lie crumpled, apologetic, prompting
rumination and reminiscence...
She started to cry,
asking God why,
why did He take her love,
why did he die!
The shirt lay there,
motionless…
vacant,
like her heart,
saying softly...
"I'm innocent!"

SORRY, BUT I AM NOT SORRY

Sorry, but I am not sorry, for being who I am,
Even if it drives you to distraction,
or puts you in a jam…
I will not lose my integrity,
to put you at ease,
and not be who I am meant to be.
Looking at it clinically,
my self-worth is not dependent,
on your acceptance of me…
I am sorry, but I am not sorry,
for my views and beliefs...
My towing your line,
would only give me grief...
I wasn't put on earth,
to bring you relief...
I am sorry, but I am not sorry,
for not riding on your bandwagon...
You can mount your high horse,
with careless abandon...
A 'yesman' I will not be,
I'm sorry, but I'm not sorry,
for being true to me!

Lillian Khan is a Brampton poet, former advertising/marketing consultant, and currently a human resources licensed payroll compliance practitioner. An immigrant from India, who now calls Canada her home. Coming from a family of educators, she has always believed in learning for life. She will be publishing her first book of poems in early 2017, in which she captures her journey through life from the soul perspective.

Peter Jailall

MY FORBEARERS

Down the Hoogly River
In British India
Across the *kala pani**
To British Guiana
My brave ancestors came.

They arrived weather beaten
In brown Demerara
Cast ashore by the cunning bacra**

They came in quietly
Full of innocence, full of hope
Without suitcase or passport

They came with seeds
Stitched neatly in their deep duckrie
Bigan bindi and *poi bhajee***

They came barefoot, empty-handed
Ready to tramp
In the swamp.

They came with determination
And ambition
Escaping floods and droughts
Trickery and poverty
Only to face the sting
Of massa whip.

Bearing pain yet again
Still they remain.
*black water **white man ***eggplant okra and vegetable*

A contemporary line drawing from an historical photograph of East Indian indentured labourers disembarking at Port Georgetown, Guyana. Circa early 20th century.

CATCHING THE LAST BOAT

On September 4th, 1955
The Last Boat left Georgetown
With 243 homesick souls
Who 'rose up' to return
To their ancestral home
Accompanied by Guyanese
Uncle Chabby Ramcharran
Interpreter, counselor and comforter.

On the last call
Just before boarding the MV Resurgent
One passenger stepped back
With a sudden change of heart –
"Na me bhaya"
He refused to go on board
He had found a new India in Guyana
With cane fields, rice fields and coconut walks
Trees laden with mangoes, tamarind
Guava and sapodilla
Mosques and temples dotting the landscapes
Fast flowing rivers
Ready to swallow the ancestors' ashes

But Gabergeela
Boarded with his adult son
Whom he snatched in the middle of the night
From his pregnant wife
With a dream of resettling
In the village of his birth.
When the boat entered the Pagla Samundar
At the horn of Africa
Gabergeela was terrified
As the boat ploughed on
Until it reached its destination

He disembarked tired, confused, disappointed
There were no friends or relatives
To greet him
He grieved and he cried.
He had returned to a nation just born
Struggling with its own birth pains
Its leaders too busy, too reluctant
To embrace these comebackees.
Gabergeela died.

He left a sad, homesick son
To search, to wander

And to finally return to his family
In Guyana,
The land where he belonged.

Peter Jailall *has been teaching in Canada, the U.S.A. and his native Guyana since 1965. He is a multiple award-winning poet, storyteller, and author of nine books, including* This Healing Place, *1993,* Yet Another Home *1997,* When September Comes, *2003,* Mother Earth: poems for her children, *2009,* Sacrifice, *2010,* Jottings, *2014;* STOP! STOP! Don't be a Bully, *2015.*

FOREVER PRESENT

In those narrow alleys
of Karachi's Bohri Bazaar and Zainab Market
and on the unpaved streets
of Rawalpindi's Mauthee Bazaar and Gakkhar Plaza
Where the South Asian population density
announces itself, along with loud horns
Where the disparity
between the haves and the have-not's
boldly stares you in the face
I was feeling, behaving
like a foreigner
I had become a Canadian!

A million eyes were staring at me
as I fumbled my way through
clumsily attempting to avoid the potholes
trying to latch on to my father's hand
walking behind him like a little girl, excited, intimidated
he was taking me shopping
Boys under ten followed us selling hair pins, *kamarbands*
Though my family drags me to shop
at the air-conditioned Park Tower in Karachi and
Jinnah Super in Islamabad,
 how can I ever forget
 that unique experience of my saree shopping?
What a treasure island of precious collections
glitter and glow instantly bedazzled me so
different from the Eaton Centre of Toronto
From vibrant fabrics of home grown cotton
to hand-woven pure silks with intricate designs
by the artisans of Pakistan

Amazing talents busy at work
in those little cubicles, the gold mines
'If only they exported half of it,
the country might not be as poor, perhaps'
naïve thought flashes through my mind
As we entered each shop
young boys were ordered by older men:
"Oeye, Chautay!
Saab te Begum Saab de waastay thanda jaa Fanta laa"
Salesmanship at its best, cold drinks ordered
pedestal fans instantly turned on
To prevent my hair
from blowing off my skull altogether,
I covered my head with my flimsy chiffon *dupatta*
Instantly blended in with the locals – a sense of relief
Another slender young boy hopped on a tall wooden stool
started modelling glamorous *saree* after *saree* for us
how swiftly he pleated each six yards of fabric
between his forefinger and his thumb
After twenty years of experience I felt like a novice
He firmly tucked in the pleats around his waist and wiggled a little
spread out the embroidered *palloo* on his left arm,
tilted his neck with joyful pride, a perfect model
the wobbly stool his risky catwalk!
I tried to replace his masculine face with mine
"Oh, I like this one. *Ouf Allah,* look at that one so exclusive!"
I was falling for every second item presented
yet he continued to fuss, his firstborn pet child
being pampered with a special treat
I liked one so much I declared:
"This is it *Abbajee.* My heart is dead-set on this one"
"Too much glitz for your mother's exquisite taste"
 "Ah, so this isn't for me?"
Surprised, shocked, disappointed, excited –
talk about mixed emotions, I felt them all
 "Don't you know? It's our 45th anniversary?"

We brought home a classy masterpiece, a surprise
that six yards of silk in grey
delicately embroidered with dusty rose
 I never will forget that evening
 how he stood in the doorway
 as I helped my mom dress up
His smiling green eyes sparkling with admiration
love radiating from him
Stunningly beautiful, she cast her magic smile his way
"My Mona Lisa," he said. A compliment to her, joy for me
…………..
As we recently bid her farewell
my sister handed me a package with a note from mom:
"From your father with love"
…………………..

Zohra Zoberi *writes prose, poetry and plays in English and Urdu. A recipient of several literary and performing arts awards, she has also been recognized by the Government of Ontario for raising inter-cultural awareness. As an active member of various literary organizations in GTA she continues to spread her artistic message of "Enlightenment through Entertainment." Her poetry, plays and short stories are published in numerous anthologies in Canada and USA.* True Colours *(an eclectic collection of prose poems won her the Woman of Courage Award (Endless Possibilities). In 2015, she was short listed for the Hazel McCallion Volunteer Award for Community Services.*

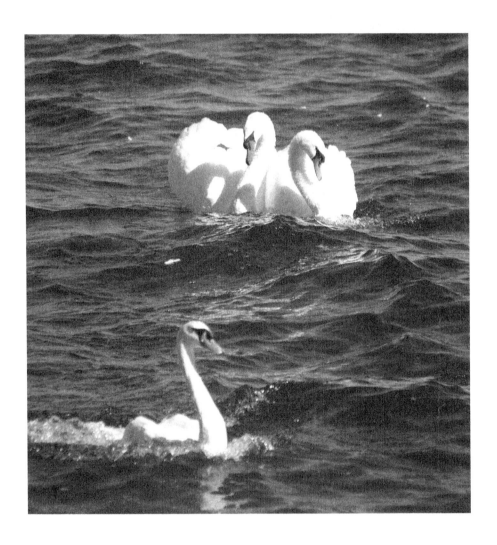

Cheryl Antao-Xavier

TEACHING MOMENTS

Will I forever watch for clouds
to darken my horizons?
And miss the flowers at my feet
picked by small, loving hands?
Innocent eyes watch me
Tiny feet shuffle in my footsteps
My every mood caught and
Mirrored with frightening clarity.
Forcing me to
Weather storms
And look for rainbows.

SILENCE IN THE BELL TOWER

No wedding bells sound
For these two
Who defied God's…?... nay, man's rule
That forbids conjoining of
God-made creatures of same sex.
Joy and pride and love ring out

The silence is deafening in the bell towers.

EXPERIMENTATION

He walks out the door
All 18 years of over-confidence belied
In the nonchalance of his slouch.
I question...or pry he says...
Where are you off to? Who with?
Do you know what curfew means?
Seeking to forestall mishaps,
Getting nowhere close to the attention
My own mother received
 When instilling the fear of God and man,
 Sending us—her daughters—off into life—
 Quiet, reserved, cautious—
 Forewarned of the vices that stalk virtue.
 Her way of looking out for us.

Not wanting to hold him back
I ease up on the reins of parenting.

He walks out the door
Teenage eagerness ready to experiment
Along the boundaries of vice and virtue
To decide for himself which is which.
My heart follows him with a blessing.

CAT INSPIRATION

There's my neighbour's cat again.
What's she going to teach me this time?
I lay down my book to watch
As she ambles across our driveway
Pausing to inspect random objects
Batting lightly at each with an inquisitive paw
At ease in the moment

I recall tranquil moments years ago
When as a child I wandered around our yard
In the afternoon sunshine
Picking up stones and random things
Creating stories in my mind about them
At ease in the moment

I watch from the window
Wishing I could ease once more into
A pure carefree stress-free being
Without the twinge of guilt
Whisking me back to the present
To chip away at
My never-ending to-do list.

Digital illustration by Shirley Aguinaldo

FROM SIN TO SMALL INIQUITY

*"God sees your iniquity – even before you commit it
Lucifer will claim you, if you do not repent"*

My pre-teen mind baulked at the big words that added mystery to the
 Great Mystery

It was not fear of God or Lucifer
That took me to the confession box
Between parent and catechism teacher
There was never an option.
I peer up at the silhouette behind the screened window
Did he really stand in for God?
He who had caned the boys in front of the girls
Just to prove his power?
Did he recognize me on this side of the screen?
As I did him?
I never tell him my real sins
Just repeat the sample sins the catechist taught us
Confessed to a lie or two—'venial' sins.
Confession boxes are stifling hot
Like Hell?
Guilt trickles down my neck
Soaks the collar of my polyester dress
My hand in my pocket clutches the four *annas*
Meant for the collection box
It was enough for two pieces of fudge
From Vellozo's snack shop

God sees your iniquity before you commit it
What does iniquity mean anyway?

I accept my penance and leave
The four *annas* lay on the window sill.

THE LITTLE RED STREAMER

Years and years ago, I turned on the ceiling fan and a wisp of red crepe paper streamer—left over from the Christmas decorations—began a slow circle above, waving in the fan's motion, 'Look at me! I am here! Remember the fun and festivity?' Then picking up speed and frantically whirling around in a blur.

Today, an ocean away, I delight in recreating Christmases past in true Goan tradition—new clothes for the season; tedious-to-make and cholesterol-fat-sugar-packed, delicious homemade sweets and cakes. I hope to pass on the joy of that wonderful memory to my kids. Keep the tradition alive.

BUT.

Husband and I are generally alone making the sweets. Precious well-used book of Goan recipes duly consulted. On the big days, turkey and trimmings sit beside *sorportel* and *sannas*, the former disappearing faster than the latter. "Mum, do you know 'sop-a-tell' has organ meat—so like, packed with cholesterol—so like, not good for you and Dad?" Followed by the totally demoralizing: "Don't cook it before my friends come over."

The sense of obligation to pass on traditions and good memories of Christmases past gets less duty-bound as the years go by. And the strong energy and digestion involved in upholding them grows lesser and lesser as well. "This is how we did it! It was such a grand time! Really. It was! A grand time!"

I feel the angst of a forlorn wisp of red streamer waving and whirling on the ceiling fan.

BEFORE WE MOVE ON...

Tribute to my uncle Tony Fernandes (died 2016 aged 91)

Before we move on
Past our bereavement
Resuming our busyness in the daily rhythm of life
We pay tribute to one we have lost
Who at one time
Stood at the crossroads of our lives
Beckoning us
Clearing a pathway through obstacles
Setting us off onto new possibilities
A new life of our own
And for those who came after us.
Familial bonds—strongly engrained in him
May fray and release their hereditary hold
As the years and generations pass
But his legacy of duty and caring –
Vast in its outreach to family and friends –
Changed many a destiny.

Before we move on
We reach out in spirit
And lay thoughts of gratitude
Like forever-flowers
In his honour
On altars of cherished memories.

Cheryl Antao-Xavier *is a poet, children's author, editor, and publisher. She published two poetry collections* Dance of the Peacock *in 2008 and* Bruised But Unbroken *in 2011, and began a children's book series* Life in Maple Woods *with* 'The Adventures of Kamal the Two-Humped Camel' *in 2015. She is currently working on two non-fiction books* Whose BLEEP Book is this Anyway? *and* PATHWAYS— to better writing! *both due for release in 2017.*

COMING 2017

THE LITERARY CONNECTION
VOLUME IV

THEN and NOW

For details go to
inourwords.ca\anthology

CPSIA information can be obtained
at www.ICGtesting.com
Printed in the USA
LVOW04s1156221016

509506LV00001BA/3/P